GROWING UP
GUGGENHEIM

Growing Up Guggenheim

*A Personal History of
a Family Enterprise*

PETER LAWSON-JOHNSTON

foreword by
JOSIAH BUNTING III

ISI BOOKS
WILMINGTON, DELAWARE

Cataloging-in-Publication Data

Lawson-Johnston, Peter.

 Growing up Guggenheim : a personal history of a family enterprise /
Peter Lawson-Johnston. — 1st ed. — Wilmington, Del. : ISI Books, 2005.

 p. ; cm.

 Includes bibliographical references and index.
 ISBN: 1-932236-57-0
 978-1932236-57-6

 1. Guggenheim family. 2. Solomon R. Guggenheim Museum.
 3. Art patrons—United States—Biography. I. Title.

CT274.G84 L39 2005 2005921372
929/.2/0973—dc22 0505

All photos not otherwise credited are used by permission of Peter Lawson-Johnston and the Guggenheim Foundation.

Letters from Adlai Stevenson to Alicia Patterson: May 1948 [?], Feb. 28, 1949, Apr. 5, 1949; Adlai E. Stevenson Papers; Box 63, Folder 3; Public Policy Papers, Department of Rare Books, Special Collections, Princeton University Library.

Published in the United States by:
ISI Books
Post Office Box 4431
Wilmington, DE 19807-0431

Interior design by Sam Torode
Manufactured in the United States

*To my wife, my children,
and my grandchildren*

CONTENTS

Foreword, by Josiah Bunting III ix

Prologue I

I. Grandpa Solomon
The Museum's Founding Father 7

II. Growing Up Guggenheim
A Grandson's Unlikely Ascent 25

III. Cousin Harry
The Heir Apparent 6I

IV. Tom Messer
The Guggenheim Comes into Its Own 83

V. Cousin Peggy
Return of the Prodigal Daughter 95

VI. Tom Krens
Toward a Global Guggenheim I09

Epilogue
Global Art as a Family Enterprise I35

Acknowledgments I43

Index I45

FOREWORD

On hearing that his friend John Hay was about to turn fifty and had proposed to write his memoirs, Mark Twain reminded Hay that, if he made a serious job of it, his "facts and fictions would co-operate loyally together for the protection of the reader." Twain knew that the alert reader can tell what the writer really means—and what the memorist *himself* is really like. To this wicked observation we may add a corollary. In his descriptions of everyone else, the memoir writer is invariably painting a full self-portrait.

Mark Twain's comment applies well to *Growing Up Guggenheim*, Peter Lawson-Johnston's admirable memoir of a number of interesting lives (almost all of them Guggenheims) that is also, concurrently, an account of his own boyhood, educational and professional experiences, his marriage and family, and—central to his narrative—his cousin Harry Frank Guggenheim's selection of him as principal heir. Harry had proceeded in the manner of Roman emperors: when the time came, he would not be strictly bound by family expectations, blood, and chronological precedence. He would designate as heir a younger person, probably, but not necessarily a near relation, who seemed to him most capable of growing into the responsibilities Harry would bequeath. The moment of Peter's selection, of his learning of it, is the most dramatic in the book: from his hospital bed Harry asks Peter to open an envelope he has been given by Harry's assistant:

"I saw at once it was his will. I . . . began to realize that Harry had decided to make me his principal heir." There follows an enumeration of the various properties to be conveyed. Then: "Harry had also bequeathed to me the mantle of responsibility for all of the Guggenheim enterprises and philanthropies directed by him."

The range of these activities was and remains extraordinary. But the diligence, efficiency, elegance, and success with which Harry's heir has presided over these "enterprises and philanthropies" has been even more extraordinary. "Peter," Harry continued, "I have been watching your progress over the past several years and there is no one else to whom I could comfortably entrust this responsibility. And you are a gentleman."

This exchange occurs at the midpoint of Lawson-Johnston's memoir. What precedes it is an account of an American boyhood superficially glamorous and enviable but fraught with disappointments, strange cruelties, small terrors. Having last seen his English father at the age of three, Peter meets him again at age twenty, in the Plaza Hotel, having first tremulously inquired of another gentleman whether he is waiting for someone: "None of your damn business," comes the reply. He finally meets his father minutes later, the somewhat raffish John Lawson-Johnston. The author also quietly chronicles his relationship with his mother Barbara (Solomon Guggenheim's daughter)—and with her later husbands. He recounts his years at The Lawrenceville School and his relationship with a remarkable master there who became a surrogate father. Then there is his stint, in 1945, as an Army PFC in charge of the Excelsior Hotel in Rome, and his discovery that the hotel has been functioning as a place of entertainment for general and field-grade officers of the allied forces. The means of their entertainments have eluded prior MPs by means of the hotel dumbwaiter. Peter's deft resolution of the problem results in the offer of a commission in the Army!

In telling the Guggenheims' story, Peter also tells the story of the Guggenheim itself—the story of how Solomon's convention-shattering abstract art collection, first housed in his Plaza suite, later found its permanent home in Frank Lloyd Wright's magnificent New York museum, which shattered a few conventions itself. Under directors Tom Messer (whom Peter inherited from Harry Guggenheim) and Tom Krens (whom Peter hired), the Guggenheim has grown from its New York confines to a global art endeavor, with new homes ranging from Frank Gehry's astounding Guggenheim Bilbao to the Las Vegas Guggenheim "jewel box." Peter's behind-the-scenes accounts of the Guggenheim's day-to-day management is an

education in itself, and an essential complement to recent—necessarily superficial—press coverage.

Alternately funny and sad, nostalgic and pitilessly objective, Peter Lawson-Johnston's *Growing Up Guggenheim* is a remarkable portrait of a great and proud American family. And the "growing up" part is only the beginning. The book's accounting of Harry Frank Guggenheim's heir's discharge of the responsibilities that devolved upon him are a quiet vindication of Harry's judgment, not least in the modesty and generosity of *Peter's* judgments of his own generation, and of the achievements of the present generation of this rare American family. It has brought new meaning to the term "giving back."

JOSIAH BUNTING III
New York, January 2005

PROLOGUE

In America, at least, we often hear of industrialists who are patrons of art. Once in a great while, though, a miracle occurs and art itself becomes a patron of industry. I witnessed such a miracle while dining with the king and queen of Spain in a new museum hailed by Anthony Lewis in a *New York Times* op-ed piece as "the great building of the twentieth century." The museum in question was architect Frank Gehry's monumental Guggenheim Bilbao, a joint venture of the Guggenheim Foundation of New York and the citizens of an obscure industrial city in Spain's politically challenged Basque Country. The dinner was the museum's dedication on October 18, 1997.

As chairman of the Guggenheim Foundation's board of trustees, I attended as a lavishly honored guest. Before King Juan Carlos and Queen Sofia, my 600 fellow revelers and I sat down to a splendid repast in the museum's 450-foot-long gallery, Basque leaders reveled in the success of an enterprise that had been violently opposed by some of their citizens. Indeed, a few days earlier a Bilbao policeman had been shot and killed by Basque separatists planting bombs intended to detonate during the ceremonies I was now attending.

In the months that followed October 18, the Basque leaders would prove as right as their terrorist opponents would prove wrong. In its first year, Guggenheim Bilbao would exceed our own most optimistic projections by a factor of three. More than 1.3 million visitors came to see the museum and the extraordinary contemporary art it contained. They brought with them $160 million in economic activity to Bilbao— essential support for the regional leaders' grander plan of funding other projects by

great architects to expand the city's port, renew its airport, create a new conference and performing arts center, and design a metropolitan railway.

The museum Anthony Lewis called a "symbol of the global society . . . attached to local roots" brought a new dawn to Bilbao. A magnificent work of art served as an engine of unprecedented economic development for a place most sorely in need of it. Nor did its spectacular financial productivity compromise Guggenheim Bilbao as a work of art. Scholars, critics, and his fellow architects were nearly unanimous in their assessment of what Gehry had achieved, calling it his masterpiece.

I sat in that awe-inspiring space, dropped like a massive spaceship on that unlikeliest of locales, and it occurred to me that the legendary enterprise of the Guggenheim family had come round in a shining, golden circle. What had begun with my Swiss immigrant great-great-grandfather, peddling his meager wares in mid-nineteenth-century Philadelphia, had grown through the early twentieth century into a multinational mining conglomerate that drew profits from the four corners of the globe. Newly minted family wealth in turn spawned a wide range of philanthropic endeavors, the most famous of which was and is the Solomon R. Guggenheim Museum of New York City. Now, as the twentieth century closed, the Guggenheim Museum and its governing foundation had effected a revolution in the role of museums in modern society.

As a member of this American dynasty's fifth generation, I marvel at our odd and wonderful fate. I realize also how the Guggenheim legacy, particularly in its second life as an artistic and philanthropic dynamo, has been largely the work of six people. The first was my grandfather, Solomon R. Guggenheim, one of the seven sons of Meyer Guggenheim who with their father transformed the family business from door-to-door stove and furniture polish sales to the largest mining conglomerate in the world—all in forty years. With his portion of this immense fortune, Solomon amassed a huge collection of non-objective paintings that largely defined modern art in the mid-twentieth century and formed the core of the Guggenheim collection. In one of his final visionary acts, Solomon commissioned Frank Lloyd Wright to design the magnificent (and perennially controversial) Solomon R. Guggenheim Museum in New York City.

The second was Solomon's successor, my cousin Harry Frank Guggenheim, who, in addition to directing the family's extensive business enterprises, was ambassador to Cuba, underwrote (with his father, Dan) the principal scientific research at the birth of aviation and rocketry, and, with his wife Alicia, founded *Newsday*. President of the board of the Guggenheim's governing foundation, Harry oversaw the final design and construction of the museum and the enrichment of Solomon's collection by the seventy-five impressionist and post-impressionist works that constituted the famous Justin Thannhauser bequest. He also established the Harry Frank Guggenheim Foundation to improve "man's relation to man."

The third was my cousin Peggy Guggenheim, who rebelled against her American parents, fled to Europe, and eventually amassed her own formidable collection of modern art, housed in her Palazzo Venier dei Leoni in Venice.

The fourth was Tom Messer, the Guggenheim's director from 1961 through 1988. In addition to mounting groundbreaking exhibits, from the Guggenheim's first American display of Peggy's Venice collection to an acclaimed Max Ernst retrospective, Tom also saw the museum through the years of planning and controversy that attended the expansion of the Guggenheim Museum building. And after Peggy's death Tom played a vital role in bringing her collection safely under the New York museum's stewardship.

The fifth is Tom Krens, who directs the Guggenheim today and is the principal force behind the museum's ascension to an art enterprise of truly global dimensions. Guggenheim ventures from Bilbao to Las Vegas to Berlin are all Krens's brainchildren, as are showstopping exhibits from motorcycles to Armani.

I am the sixth individual to help roll the great Guggenheim wheel its last turn. The five before me are my relatives, colleagues, and friends. In this book I tell the story of the Guggenheim through the stories of these remarkable people—a "Guggenheim Gallery," if you will. Dozens of books have been written about my family, its fortune, philanthropy, museums, and art collections. But with two exceptions—Peggy's 1946 autobiography and a 1998 celebration of Peggy's life by her granddaughter Karole Vail—no books on these subjects have been written by Guggenheims themselves. Nor has any book attempted to cover the explosive

evolution of the Guggenheim's art enterprises over the past fifteen years. All await more intimate treatment than writers outside the family can provide.

To tell the stories of the people behind the Guggenheim I must tell my own as well. I grew up on the fringes of the family empire (though in childhood I was close to my grandfather Solomon), began my career as a reporter for the *Baltimore Sun* (under the jaded eye of a young rewrite man named Russell Baker), and entered the Guggenheim fold when I was thirty years old as sales manager of a remote feldspar mine. Through a series of extraordinarily fortunate encounters, I grew close to my cousin Harry and in time inherited his principal business, artistic, and philanthropic legacies.

From that position, I have been lucky enough to oversee the evolution of the Guggenheim from a rather small New York museum to a global institution. I worked with Tom Messer to move the Guggenheim New York's expansion through complex architectural plans, Byzantine city zoning laws, and ever-sharp Manhattan public opinion to a widely praised conclusion. I took the museum's foundation "public" so that we could raise funds beyond its insufficient endowment for expansion and improvements. I worked with Peggy Guggenheim to transfer her collection and Venetian palazzo to the New York Guggenheim's ownership. And in 1988, when Tom Messer retired after twenty-seven years as the Guggenheim's director, I took Tom's good advice and hired Tom Krens as his successor.

Two points of irony in all this: first, when I accepted the Guggenheim legacy and its responsibilities I had no ambition beyond sustaining the great works of my forefathers. In a 1978 *Town & Country* article, I described my job principally as one of stewardship—"not to trail blaze, but to make our forebears proud of the vehicles that bear their names."

Second, I am neither a collector nor a particularly astute judge of art. People are frequently surprised that my contributions to the Guggenheim are those of a business manager. They needn't be. The international language of art institutions is also

the language of business: stewardship, management, acquisition, showmanship, and solvency.

Although I am sure my grandfather never envisioned a global Guggenheim when he decided to house his collection in Frank Lloyd Wright's incredible building, I think he would have been as pleased as I am that we are blazing a new trail in the museum

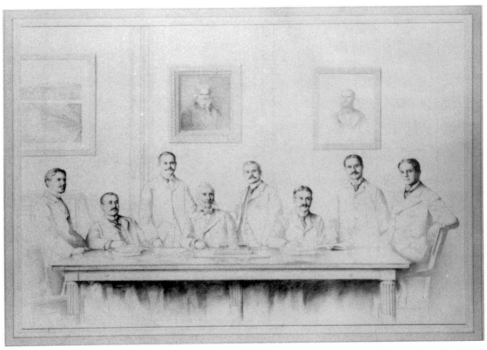

Meyer Guggenheim and his seven sons, drawn by Frederick Wallace in the early 1900s

world, making it possible for people in faraway places to view the Guggenheim's collection. Perhaps the real secret of the Guggenheims' success in the world of art is that, with the stunning exception of Peggy, few of the Guggenheims, whose name is practically synonymous with the art of the twentieth century, have themselves been deeply informed collectors or curators.

This may seem a wayward observation, as Solomon is the man whose enormous collection is the heart of the Guggenheim Museum, but Solomon himself gave most

of the credit to his advisor, Baroness Hilla Rebay von Ehrenwiesen. As we will see in Chapter I, however, the baroness gave all credit to Solomon for those talents we would normally call "business acumen," which were in large measure responsible for the success of the early Guggenheim's entire enterprise.

There may be a lesson here. Business and museums can learn much from each other, and most museums can be run more efficiently by employing more sophisticated management practices.

I know little about art that art professionals would deem important, but I know enough, and have seen enough, to believe that art can unite disparate peoples. If the final legacy of the Guggenheim dynasty contributes to such transcendent discourse—as in Bilbao's marriage of global American art enterprise and venerable European culture—it will be a most remarkable and just conclusion to a story that began when a poor Jew wandered from the Old Country toward the unlimited horizon of the New World.

I

GRANDPA SOLOMON
The Museum's Founding Father

My great-great-grandfather Simon and his son Meyer arrived in Philadelphia in 1848 from Lengnau, Switzerland, after a two-month sea journey. One of two towns in all of Switzerland where Jews were allowed to live, Lengnau had for generations offered Meyer's ancestors neither opportunity nor security. Forbidden to own land, Lengnau Jews were allowed to work only as peddlers, tailors, or moneylenders. The Swiss authorities confiscated income beyond that which provided a meager subsistence.

In search of anything better than the bleak future preordained in their homeland, the Guggenheim family joined the great nineteenth-century European exodus to America. Virtually penniless, father and son became door-to-door peddlers. Meyer, in his early twenties, was particularly successful at selling stove polish to farmers and miners in the Pennsylvania Dutch country. Soon, the Guggenheims set up a business to manufacture stove polish and, later, something called "coffee essence," a concentrate made principally of chicory.

By 1852, Meyer, at twenty-five, could afford to marry his nineteen-year-old sweetheart, Barbara Meyer, with whom he had fallen in love on the voyage to America. By 1873 they had eight sons and three daughters.

After Simon died in 1869 at the age of seventy-six, Great-Grandfather Meyer expanded the family business by becoming a wholesale spice merchant, manufacturer of lye, and importer of laces and embroideries. He and Barbara had eleven children:

daughters Jenette, Rose, and Cora, and sons Isaac, Daniel, Murry, Solomon, Benjamin, twins Simon and Robert (Robert died at age nine), and William. A harddriving man, Meyer was devoted to his family and determined to instill ambition in his seven surviving sons so that they could ultimately join him in the family business. Barbara, who had no interest in business, apparently was a truly dedicated mother who enjoyed that role enormously. In addition to creating a warm home for her family, Barbara instilled in her children a love of music and the arts and supported their philanthropic inclinations.

My great-grandfather Meyer Guggenheim

The children attended Catholic day schools in Philadelphia. In their late teens, Dan, Murry, and my grandfather Solomon were sent to Switzerland to learn the embroidery business. Upon their return, Meyer formed a partnership, M. Guggenheim's Sons, giving each son an equal share, even though the older brothers shouldered most of the workload in the early years. A family story that passed down to my generation tells how Meyer once gathered all the brothers together, handed each a stick, and asked him to break it. He then had each brother attempt to break seven sticks together, which none could. His moral: in unity, strength.

In 1881, Meyer learned of a silver and lead mine in Leadville, Colorado, that was for sale because it was flooded. He invested in what became the famous A.Y. and Minnie Mines, which turned into a bonanza. Soon the Guggenheims were deep into the highly profitable mining business.

Grandfather Solomon, at thirty, was sent to Mexico in 1891 to supervise the construction of a smelter in Monterrey. I've been told he carried a loaded revolver at all times and proved to his father and older brothers that he was both courageous

and effective. Ultimately, the Guggenheims dominated copper, lead, and zinc mining and smelting in the U.S., owning or controlling American Smelting and Refining Corporation, Kennecott Copper, and others. In the years prior to World War I, the family had secured control over as much as 80 percent of the world's copper, lead, and silver mines.

At the peak of their success they discovered the famous Chuquicamata Copper Mine in Chile, owned diamond-mining operations in the Congo and in Angola (in partnership with Thomas Fortune Ryan and Société Générale de Belgique), gold mines in the Yukon, and copper mines in Alaska. When Meyer died at seventy-eight in 1904, he left each son a multimillionaire.

Their liquid assets were vastly increased in 1923, when my grandfather and three of his brothers decided to sell Chuquicamata to the Anaconda Company for $70 million (more than $700 million in 2002 dollars). Because their decision was made over the objections of Dan's son, Harry, and Murry's son, Edmond, the Chuquicamata sale scattered Meyer's hallowed "bundle of sticks" for this and succeeding Guggenheim generations. Nevertheless, that 1923 sale left each of the Guggenheim brothers among the wealthiest men in the world, and each in his own way began to employ that wealth in ways so grand they soon eclipsed and obscured the roots of the family fortune.

Born in 1927, four years after Grandfather Solomon realized his share of those assets—and began spending them lavishly—I assumed, as children do, that his way of life was a timeless condition, not the magnificent exercise in semi-nouveau riche it actually was.

To say my grandparents lived expensively is a gross understatement, though to a measurable extent my grandfather had earned it, over and above his inheritance. My half-brother, Michael Wettach (who died in 1999), and I used to talk about the things we remembered most about our visits to Grandpa Solomon and Grandma Irene. In the end, the overwhelming luxury of their lifestyle left the most durable impression on us both.

As boys, we visited our grandparents most often at their palatial 200-acre estate, Trillora Court, at Port Washington's Sands Point on Long Island. It encompassed a beautiful nine-hole golf course, which his deceased brother Isaac had built for himself upon learning that the Sands Point Golf Club wouldn't admit him (or any other Jew). I formed a lifelong attachment to golf on that course. A much-better-than-average golfer, Solomon was portrayed in John H. Davis's monumental 1978 book *The Guggenheims* as "driving the ball past mossy baroque statues and fountains, formal Italian gardens," which as a youth I was too absorbed in the game—and still am—to notice.

Trillora was designed in the Italian Renaissance style, an immense, square, forty-room structure surrounding an enclosed courtyard. The driveway was a curving, mile-long path of small, bluestone chips. I remember waking to the sound of the grounds crew raking that endless gravel ribbon—a Sisyphean task that began again each time a car passed over it. My grandfather and grandmother each had a chauffeur. When approaching the house, my grandmother's chauffeur, Gunther, would give the horn three short beeps, while my grandfather's chauffeur, Allen, gave one long blast. These "codes" alerted the footman exclusively assigned to my grandfather or grandmother to race from the back of the house to the front in time to open the gates and retrieve his particular charge.

The other morning sound at Trillora was that of heavy steel blinds being raised outside the mansion's enormous windows. I'd bound out of bed and beat it downstairs to the formal dining room, where my grandfather and I would eat breakfast alone together before he went off to work in New York. He was an impeccably tailored gentleman, very short, perhaps five feet six inches, bald, with a prominent nose, blue eyes, and ruddy complexion, and I was delighted to have him all to myself on those occasions. We would dine on oatmeal (which my grandfather always called "porridge") topped with cream from Trillora's own dairy farm.

While Michael and I tried to be on our best behavior at Trillora, we weren't always successful. While Grandma considered me a "perfect little angel," there was the time when, at a *very* young age, I peed down the trough-like banister of the grand marble staircase. Another time, chasing a playmate down one of Trillora's cavernous halls, I

grabbed a table in order to make a quick turn, causing a priceless statuette to smash to smithereens on the floor. My mother was furious. "But the little dear didn't mean it," cooed Grandma, "and the statue didn't mean anything to me anyway." Somehow all the pieces were swept up, and on my next visit, the statuette stood in its usual place, glued back together—although I swear to this day that what had been three standing figures had become, after its restoration, two standing figures and one reclining.

When I was ten or so, after returning from his office in New York or nine holes of golf, Grandpa started inviting Michael and me to his bedroom in the late afternoon, where he would lounge in bed reading the evening paper, dressed in his silk long underwear. Jules, his valet, would draw Grandpa's bath, after which Grandpa would don his black-tie attire for dinner, with Jules's help.

Boyd, the butler, would wheel a bar into the drawing room and Grandpa would ceremoniously concoct an "orange blossom" cocktail for himself; my brother and I were given an orange juice so that we could join him in the "happy

Grandpa Solomon

hour." After dinner, we would gather around the radio and listen to Gabriel Heatter deliver the news. (As I recall, Grandpa was not an avid fan of Franklin D. Roosevelt.) Before dinner one such evening, Grandma explained at length her having bought that day an expensive necklace. Grandpa listened politely till she finished, then held up the gin bottle and said, "That's perfectly all right, Irene, but someone in the kitchen has gotten into my gin."

For her part, my grandmother was in many ways heir to the character of her mother-in-law, Barbara—sweet, affectionate, and focused on her family. Occasion-

ally she displayed the penny-wise ways my mother inherited from her. She would refold her dinner napkin around a lipstick stain, put it back in its napkin ring, and tell Boyd that it hadn't been used, implying it need not be cleaned. She kept absolutely everything, and in going through her belongings after she died, one of us found a trunk of linen labeled, "Too darned to be used." Pondering this in retrospect, Michael said, "They still knew the value of a buck."

Both of my grandparents had canary appetites and ate very quickly. Because he could drink soup that was boiling hot, Grandma used to say that Grandpa, having been in the copper business, had a copper-lined stomach. Several close family friends of their generation would stop at Howard Johnson's on their way to Trillora because they knew that the Guggenheims' meal portions were so tiny. The parents of my mother's third husband, Henry Obre, came to Sunday dinner once and watched with famished terror as a platter with one less chop than there were diners slowly made its way around the table—a gustatory Russian roulette that kept everybody on the edge of their seats wondering who wasn't going to eat.

My grandfather's recreations ranged across many interests and locales. He hunted in Scotland; on his 12,000-acre plantation, Big Survey, near Yemassee, South Carolina; and in Idaho at Railroad Ranch. He was also an excellent fisherman. When I was about eleven, Grandpa took us on a cruise on the St. Lawrence River. He sat on the stern of the boat facing aft with his fishing line dragging behind. Each time he dozed off I would strike his line with my pole and he would yell with a start, "By Jove, I've just had a bite!" Teasing Grandpa in this fashion took a modicum of courage, for I was truly in awe of the man.

Grandpa was also a yachtsman, and I particularly remember one of his more unconventional yachts, a converted World War I 305-foot U.S. destroyer he kept in Roslyn, Long Island. After the terrible hurricane of 1938 hit the area, Grandpa had his chauffeur take him to Roslyn to check on his yacht. He returned grinning from ear to ear and said, "It's a total loss." He was thrilled because he hadn't been able to sell the monster, which was fortunately insured.

A splendid raconteur, my grandfather took pains to include us in any good joke. Once, when I was a little boy, my brother Michael and I motored from Charleston to

Long Island with Grandpa and Grandma. We stopped at Mount Vernon at the suggestion of my grandmother, who was a history buff. When she got out of the automobile with Michael, Grandpa asked me to stay behind with him. He then took me by the hand and we walked across the lawn to a wooded area. "Peter," he said, "I want you to be able to tell your grandchildren some day that you and your grandfather watered George Washington's lawn."

In short, I enjoyed a warm relationship with my grandfather and grew up with an image of him as a wealthy, powerful, avuncular gentleman. Until I was an adult, though, I knew next to nothing of his roots or his fortune. (I must still consult Davis's volume for certain historical details.) And because neither he nor my mother talked much about the Guggenheims, I was until adulthood unaware of the role the Guggenheim name played in the public's consciousness, or of the complex interests and motivations that drove his life when I knew him.

Like several of his brothers, Solomon sought to repay his adopted country some of the riches he had earned over the years. His mother, Barbara, had instilled in her children a philanthropic spirit, and toward this end they all established charitable endeavors. Dan focused on supporting aviation and rocketry, Murry set up a free dental clinic in New York City, Simon created a foundation in his son's memory to provide grants to aspiring artists and scholars (still renowned as the Guggenheim Fellowships). Benjamin, a playboy who went down with the *Titanic*, contributed indirectly to society through his daughter Peggy, who amassed a great art collection. All seven sons contributed to Mount Sinai Hospital at their mother's death.

And, late in life, my grandfather Solomon began to collect the contemporary art of his time, art few Americans understood or appreciated. The driving force behind this remarkable collection, a collection that in many ways defined and established modern art in the twentieth century, was my grandfather's "confidante" (for want of a perfect word), Baroness Hilla Rebay von Ehrenwiesen. The baroness came to the United States from Germany in 1927 (the year I was born). A painter whose work had been exhibited in Germany, Switzerland, and France, the baroness brought with her a letter of introduction from my grandmother's sister. My grandmother acquired one of her works, which led to a commission to paint a full-length portrait of my

sixty-five-year-old grandfather. Hilla was dynamic, visionary, mercurial, charming, thirty-six years old, and obviously attractive to her subject.

The following year, under Hilla's influence, Grandpa began to buy abstract and other highly nontraditional paintings—works by Kandinsky, Gleizes, Delaunay, Léger, Chagall, and other artists then virtually unknown in America. The paintings were hung in my grandparents' New York apartment. As interest in nonobjective (what we would now call abstract) art began to grow, more and more people came to the apartment to see Solomon's paintings. Eventually, my grandparents began to hold a weekly two-hour open house, inviting the public in to see these strange new works. They were, of course, the modern masterpieces that formed the nucleus of the famed collection now ensconced in the Guggenheim Museum, the institution with which our family name is most identified to this day and whose board I directed for the better part of my career.

Hilla Rebay in her studio

Looking back, I'm somewhat amazed that neither Michael nor I had any real sense, as boys, of the value and importance of Grandpa's collection, though it was right in front of our eyes every time we visited my grandparents in New York City. Occupying the lion's share of the Plaza Hotel's second floor, my grandmother's and grandfather's separate Plaza domains reflected their distinct tastes in art and decor. My grandmother, whose maiden name was Rothschild ("but not *the* Rothschilds, dear," she used to say) had decorated her own suite, facing 58th Street, in "Old New York." Her sitting room, dressing room, and big bedroom were well stocked with French antiques and Persian rugs. Her paintings were beautiful and traditional: Oriental, late medieval, early Italian Renaissance, fifteenth-century Flemish.

As you left her suite, though, you entered a long hallway on the Fifth Avenue side where my grandfather's modern art reigned supreme. The walls were covered with Bauers, Braques, Chagalls, Kandinskys, Klees, Modiglianis (a magnificent nude of his was the only painting that left an impression on my boyhood memory), Picassos, and Seurats. The apartment's living room, dining room, and my grandfather's bedroom fronted Fifth Avenue (its windows surmount the flagpoles above the hotel's main entrance today); here, too, "the modern" dominated. The walls in his bedroom were covered in cork, and the toilet and sink in his bathroom were purple.

By the 1930s, the collection numbered several hundred pieces and had outgrown even the spacious confines of the Plaza's second floor. To create a nonprofit entity to manage the art, Grandpa incorporated the Solomon R. Guggenheim Foundation in 1937. Two years later he established the Solomon R. Guggenheim Collection of Non-Objective Painting—located in a former midtown car showroom—as the first independent residence of the Guggenheim collection.

Many art historians say it was Hilla Rebay who urged Solomon to engage Frank Lloyd Wright to design the Guggenheim Museum. My mother, who claimed Grandma suggested Mr. Wright, always disputed this. In the Solomon R. Guggenheim Foundation files, in the minutes of a meeting of the board of trustees held on September 20, 1954, is the following statement, which supports my mother's claim: "Mr. Wright also stated that Mrs. Solomon R. Guggenheim was responsible for bringing Mr. Frank Lloyd Wright into the picture, but that Miss Rebay had always taken the credit."

It is most certainly true that there would have been no Guggenheim Museum of *any* kind without Hilla Rebay. "Her commitment to nonobjective art might seem dogmatic today," says the Guggenheim Museum's emeritus director, Tom Messer, "but it doesn't reduce the value of what she did. She bought in great numbers, and some of what she bought wasn't great, but all of it was cheap. In the end, it doesn't matter how much of it went to the basement as long as there were pieces of great importance. As a single example, she assembled the greatest Kandinsky collection there is. And we sold quite a few things out of her 'excess' to buy new work. All in all, she did pretty damned well."

Whether Hilla was my grandfather's mistress will probably never be known for sure, but I share a prevalent suspicion with Solomon's successor, my cousin Harry Guggenheim, who once asked a nonplussed Guggenheim director, "Do you *really* think the old man rolled over Hilla?"

One of my most vivid recollections of the baroness is of a day at Trillora Court, on the first tee of the golf course, when she and my grandfather both sat and marveled at my peculiar golf swing, which, for some unknown reason, resulted in long drives down the middle of the fairway. I do not remember her drawing the three sketches of me romping in the nude at age three, which currently, and appropriately, hang in my bathroom at our Princeton home.

Unsurprisingly, considering the amount of time, energy, and money he lavished on her, the baroness was less well-liked by my mother and grandmother, who referred to her privately as "The B." Even at an early age, I sensed that "B" did not stand for "baroness." Relations were further strained after Solomon's death. Up to that point, Hilla had enjoyed near total control of the Guggenheim collection, but with Solomon gone the museum's staff and trustees felt freer to question Hilla's stewardship aloud.

As a single example of the behavior that led people to mistrust her, Hilla refused after his death to return hundreds of paintings my grandfather had lent her, denying that the museum or my family had any claim to them. Legally, she was correct, as my grandfather had made no such stipulation in his will. But in a letter to the Guggenheim Foundation a few months before his death, he wrote, "[I]t is my expectation that . . . [Hilla Rebay] will make a gift to the Foundation of her entire collection of paintings and pictures. . . . I have not provided in my Will that it is a condition of my bequest to her that she do so, principally because I do not wish to cause her any difficulties in respect to income taxes, but *she and I both understand that she will give her collection of paintings and pictures. . . .* [my italics]"

Hilla's unvarying response to any and all criticism was a torrent of defensive, patronizing verbiage, not always in perfect English. I've long cherished, with amuse-

ment and some horror, a letter Hilla wrote in response to one from my mother calling into question a few of Hilla's actions regarding Solomon's legacy. Hilla's response runs to 2,600 words and presents a remarkably candid (though entirely unintentional) self-portrait. "Who would have believed," she begins, "when in 1911 my father did

not speak to me, for three weeks, because I spent five dollars of my allowance, to buy a Van Gogh painting which he called 'trash' . . . that such paintings 30 years later would be worth $150,000. . . ."

Having thus established her bona fides, she proceeds to elevate my grandfather into her company. "[It] needs vision and brain [sic], to recognize any unforeseen cultural value as such, when it presents itself,"

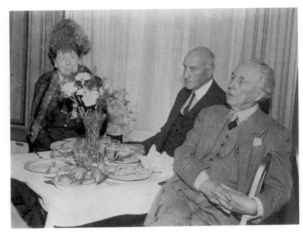

Hilla Rebay, Solomon Guggenheim, and Frank Lloyd Wright dining in the Plaza Hotel, circa 1940

she proclaims, "this faculty your father having had, not only for business, but his vision was unique, and his intuitive capacity of judgment extended even into the loftiest realm of art. . . ."

Hilla goes on to relate how, when the museum's overseeing foundation was established, she was courted to be its director. After two candidates had refused the offer ("unable to handle the difficulties to be expected"), the trustees chose her for the job. She claims she learned of the decision only when it was published in the New York papers. The news came as a nasty surprise to her, apparently. "My health being what it was at that time . . . I was frightened about this message, and so shocked that my brother found me in tears, in my Bavarian mountain house. . . ."

Duty called, however. "I did not let your father down," writes Hilla, "nor [leave] his already priceless collection at the mercy of someone's ignorance. . . . I simply had to accept and decided to make it a success," though to do so she was "forced" to sell

one of her two European homes ("households established with servants"). Her self-proclaimed motivation for such hardship duty was nothing short of saving modern art from extinction. "A new form ideal, so hard to establish, and especially a new concept as non-objectivity itself, would have fallen prey to . . . ignorance triumphantly saying, 'you see, this art is valueless and a failure.' This surely would have delayed the important influence of creative painting for a century to come."

One of Frank Lloyd Wright's early drawings for the Guggenheim Museum

The job was arduous, as Hilla knew it would be: "I had to learn many tedious, tiresome duties, such as teaching, writing, explaining, editing, lecturing, catalogueing [sic], bookkeeping, insuring, listing, historical research, and keep informed, besides daily correspondence with scientists, historians, artists and philosophers, also to watch art politics, attend congresses, and as a member of the Museums Council of New York have other duties; organizing and last but not least, attend to endlessly dull routine work."

Thank goodness for Solomon, from whom the beleaguered Hilla "learned . . . how to make the running of the office part a success. I had to stop my own painting for long periods, stop music and stop reading for pleasure. I had to give up friendships, parties, movies, theatres, riding, skiing, club life, traveling, visiting, concerts . . . so as to be able to preserve my full strength, energy, time and health. . . . With executive training, not foreseen in the academic learning for art by a Grand Prix winner of portraiture, I succeeded, however."

Hilla claims also to have saved my grandfather from the fate of a philistine: "[N]on-objective masterpieces are far too great, difficult and tedious to compose

ever to become lucrative for trade," she writes. "Your father, fortunately, did not continue to waste money on paintings of the dead past," though they promised better returns. "Instead he made remarkable investments—even if we were persecuted with vile, furiously started smear-campaigns, by all those traders catering to the then still lucrative outdated past of so-called old masters, which today are hardly getting a price."

And thus Solomon, according to Hilla, earned "acclaim of a kind, which other rich men may envy, and not even the generous Rockefellers have received. . . ." When Solomon died, writes Hilla, she "received letters even from Italy in which they call him 'a second Lorenzo il magnifico' (Medici), the same in Australia, Africa, Brazil, Argentina, and all Europe. But the Medicis only sponsored the past, while he did far more than they by looking ahead and introducing courageously not a renaissance but a naissance, not a rebirth but a birth of this new great rhythmic form ideal of the Inbetween and of our time, which the painters discovered before the scientists did."

Having (after at least the 2,075th word) come to the point of her letter, Hilla proceeds to put my mother in her place: "These facts you may not yet have understood, as your letter indicates. Your father feared sabotage of his ideas and intentions, let us hope that we can prevent that. . . ." Referring to my mother's lifelong passion for horseback-riding, she continues, "Although brought up in a family, who for centuries owned noble horses, and born to natural horsemanship, I would never attempt to give my advice or beliefs about horses to you, who are an expert in this field. I hope that perhaps some day you will believe my knowledge, in a field, where I am supposed to be an expert."

Not that the baroness expects, in the end, ever to be fully understood or appreciated: "Jealousy and stupidity meet always anything that is unfamiliar and great. . . . Yet a high mountain takes time to climb, all the further the view once one reaches the summit. However, there is no hurry where there is eternity."

As evidence that their relationship failed to improve over time, I offer my mother's response to the baroness's letter of sympathy when Grandpa died. Her mother, Irene, vetted this rough draft. Note Irene's excisions and (boldfaced) additions:

Thank you for your kind letter of sympathy. I am afraid I did not always give my father so much joy though in later years I have caused him no sorrow—however one often loves those best who cause the worst trouble.

As for the foundation, I feel that it is what one <u>believes</u> that is important. You made him believe he would be remembered because of his art collection which thought gave him great pleasure. Therefore that was what mattered most. He made his own ~~money~~ **fortune** & it was right that he should spend it ~~to benefit himself~~ **as he wished.**

<u>My</u> belief is different. ~~I feel that most artists are rather odd & many quite degenerate. He might have used his money to better advantage.~~ However the building [Frank Lloyd Wright's Guggenheim Museum] will be a tremendous factor in promoting the whole ~~thing~~ **project** and I am looking forward to the day of its completion. My one desire is to have his wish come true. I am glad that you, with your great energy, are working to this end.

Books about the Guggenheim collection tend also to cast Hilla Rebay as its exclusive genius, with Solomon serving merely as her bankroll. I offer some thoughts to the contrary, a small portion of which are provided by the baroness herself, who said in that same voluminous letter to my mother, "Your father was the very last person who could have been 'made to believe' something if he did not fully believe it himself. He certainly would never have spent even a nickel on anything he did not wish to own. [He] had a great deal of culture, as he could do what only the cultured can, without knowing titles and artists to pick the first, second and third best paintings in any exhibition. . . . Nor did he have to read, usually doubtful books, self-called critics. . . ."

Solomon himself, near the end of his life, recalled the first time he saw a non-objective painting in Europe and how he had been "enchanted by its appeal." He also expressed an impressively prescient view of the form's American potential. "It is a field in which I believe American painters should be particularly apt," he wrote, "because of the American's unusual feeling for rhythm, and I am confident American painters will exceed all others in this art of pure creation."

In true Guggenheim fashion, Solomon also found *practical* value in modern art. "There is ample indication," he wrote, "that this art can help to build up the rhyth-

mic sense of children from an early age and can be of great assistance in the development of their creative powers and in the appreciation of aesthetics. I have lived to receive many reports to this effect from educators and teachers, and to hear design-

ers, industrialists, physicians, students, even prison authorities, attest to the great influence of non-objective painting in the advancement of man."

In the end, though, his own attachment to these works was deeply personal and emblematic of the universal attraction of all great art. Years after his death, the museum de-accessioned a Bauer considered one of the artist's minor works. Realizing it was one of Grandpa's favorites, which once occupied a place of honor on his bedroom wall, I bought it myself and have become as affectionately attached to it as Solomon once was.

Like Hilla, Solomon was keenly mindful of the status quo's resistance

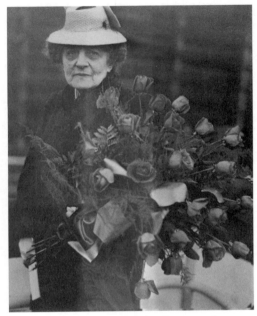

My grandmother Irene, christening an oil tanker in 1947

to radical innovation. "In spite of much misunderstanding," he told the Guggenheim's trustees, "and almost discouraging advice in the early stages of this endeavor, I have enabled your Foundation to acquire for the benefit of the public the largest and, I believe, the finest collection of non-objective painting in the world. I have never regretted my intuitive decision to promote this form of art, nor has my great faith in it diminished. As its influence has grown on me I have wished only to enable others to appreciate it." Though warned by Hilla that he wouldn't live long enough to see his vision validated, he was pleased to note that "letters, articles and visitors, not only from this country but from art centers throughout the world, give us daily evidence of success."

Although Grandpa and Grandma were Jewish, I have no recollection of their practicing any religion or attending any church or synagogue services—with the grand exception of Grandpa's funeral in the huge, ornate Temple Emanu-El on Fifth Avenue. I recall looking back during the service and noticing Bernard Baruch, the famous advisor to presidents of the United States, who had been close to the Guggenheim family, sitting alone in the last pew, paying his final respects.

I admired my grandfather enormously, and I think ours was a rather special relationship because he never had a son. It was a blow to me when he died in 1949, in his Plaza Hotel apartment. I particularly treasure this letter, received along with a check for $250 on my twenty-first birthday, one year before he died, after my army service in Italy:

February 6, 1948

Dear Peter:

This birthday brings you to the age at which every young man is proud to arrive! Your twenty-first milestone will mark the beginning of one very important privilege not possessed heretofore, and that is the privilege of [voting]. With each successive birthday, you will realize more and more the meaning of this honor and duty of every American citizen.

I have known many young men during my lifetime to reach this important Age 21, but I can truthfully say, and without any flattery, that I know of none who have been better equipped to accept its responsibilities than you. This knowledge, Peter, has made me very proud, and I want to wish for you, along with my heartiest congratulations, the very best that life has to offer. Gran joins me in this wish, and also in the little birthday gift I enclose herewith.

With love and repeated good wishes for you today, and always, I am
Your affectionate Grandpa

Solomon R. Guggenheim epitomized material success in life, but more than that he possessed great wisdom and dignity. Looking back, I believe my desire to succeed in life owed much to my hoping he would be proud of me someday.

Trillora passed out of our family's hands after Grandpa died. Until 1994 it was owned by IBM, which used it as an educational and recreational facility for its employees. Most ironically, given Trillora's birth as Great-Uncle Isaac's haven from restrictive country clubs, Trillora is now a private country club, The Village Club of Sands Point. I am assured that the Village Club's membership policies are more open than were those of such clubs in the early twentieth century.

My grandmother—whose support of Solomon and her family so clearly echoed that of the family matriarch, Barbara Guggenheim—had a stroke soon after Grandpa Solomon died. My only real tie to my mother's side of the family was now gone.

II

GROWING UP GUGGENHEIM
A Grandson's Unlikely Ascent

"To the Guggenheim manor born," I suppose I might have risen rapidly and easily to the top of the family enterprise. Indeed, many people who learn of my blood relations understandably assume I simply inherited the Guggenheim legacy by birthright. In fact, I had to work my way from the hinterlands to the center of the Guggenheim enterprise. My childhood "drift" from the heart to the periphery of the family is explained by the story of my mother, Barbara Guggenheim, her complicated relationship with her parents, and her lifelong quest to find her own place in the world.

My mother was the youngest of three daughters. (Eleanor, the eldest, married the Earl of Castle Stewart, an Irish peer, and lived most of her life in Sussex, England. Gertrude, the middle daughter, never married and chose to live near Eleanor in Sussex.) As a young girl, Barbara romped through all of my grandparents' various domiciles, but the Plaza always felt most like home to her. As an adult looking back on her girlish antics there, my mother wondered whether she had been the real-life model for the title character in *Eloise*, Kay Thompson's famous children's book about a mischievous six-year-old who lives at the Plaza and terrorizes the hotel staff.

Clearly, Barbara Guggenheim was a privileged child, and it was said that her parents doted on her even more than they did her older sisters, Eleanor and Gertrude. But Barbara herself felt that her parents were unduly strict, and she couldn't wait to escape what she called their "oppression." I have never been entirely clear as to the

nature of this oppression. She was crazy about her father, and he about her. But she was also a little afraid of him. He had always wanted a son, and Barbara offered him the next best thing: a tomboy. From early childhood, she was a fine tennis player and a superb equestrienne. In support of the latter activity, Grandfather Solomon went so far as to build her a stable on the grounds of Trillora Court.

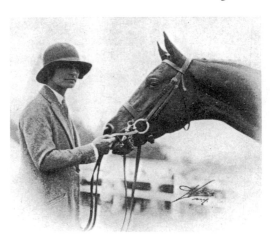

My mother, Barbara Guggenheim, at a horse show on Long Island in 1926

It may have been the pressure of her father's expectations that drove Barbara from the house at an early age. It may also have been a more mundane reason: Like most children of her generation and means Barbara had a governess, and in those days a governess was often more domineering than any parent could be. Finally, I believe that Barbara yearned for a somewhat simpler, less complicatedly lavish lifestyle than the one in which she had been raised. She wanted to live life on her own terms.

At age nineteen, on a grouse-shooting trip with her family on the moors of Inverness, Scotland, Barbara met and fell in love at first sight with John Lawson-Johnston. Grandson of his namesake (the inventor of Bovril, the world-famous beef extract), my father had attended Eton, where he launched his career as a playboy. His mother was Fannie Dunlap from Savannah, Georgia, who died while John was still attending Eton. Although his father Ormond was British, he and Fannie were living in New York when Dad was born in 1902, so all his life my father enjoyed dual citizenship.

Barbara and John married in 1925, soon after they met. After their splashy wedding in her parents' Plaza suite, they lived for the early part of their married life near Dupont Circle in Washington, D.C., where my father was attached to the British Embassy. They did quite a lot of entertaining, even though Prohibition was in effect.

Dad, I was told, brought Scotch whiskey into the country in diplomatic pouches "under His Majesty's Service."

While my mother was perfectly capable of entertaining important guests in the proper manner, she was never comfortable with it. She would fret for an entire week before a Saturday night dinner party, worrying about the placement of each piece of silver. Her new husband made things easier for her. He was a terrific practical joker whose gentlemanly English demeanor and uncanny ability to keep a straight face in unlikely circumstances allowed him to get away with social murder. He used to drop hot pennies from the Guggenheims' hotel suite onto the 58th Street sidewalk in order to observe the reactions of those who picked them up. He would take a supply of starched shirt collars to the ballet and rip them as the dancers leapt through the air, perfectly mimicking the sound of tearing tights.

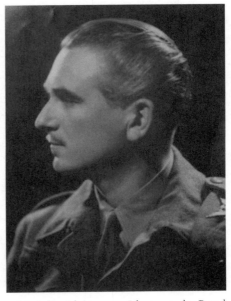

My father, John Lawson-Johnston, in his British Home Guard uniform during World War II

All of this may have been inappropriate and undignified, but Barbara loved it and learned to follow suit. She once sat next to a rather stuffy Englishman at one of their formal dinner parties. When she asked what he did for a living, he haughtily replied, "'Do,' Madam? I don't 'do' anything. I'm a peer of the realm." "Oh," she replied, "In America, we would call you a bum."

To enliven her social obligations as a diplomat's wife, Barbara introduced scavenger hunts to Washington society. Dinner guests were induced by the chance of winning a lovely prize to chase all around town, plucking horse-tail hairs, obtaining autographs from startled senators, securing blue toilet paper, brassieres, and so on. The first couple to retrieve all these items was declared the winner. On one such hunt, the prize was found dangling on a string over my parents' indoor swimming pool.

Incidents like these may have put a strain on her husband's career in public service. In any case, Grandpa Solomon Guggenheim, seeing no future for Dad in diplomacy, persuaded him to take business courses at Columbia University and then brought him into the Guggenheim Brothers office on the thirty-fifth floor of 120 Broadway so that he could learn about accounting and earn a living to support himself and my mother. (He had long since run through his own small family inheritance.) Alas, Dad carried old habits to his new job. I am told he amused himself during his short-lived career at Guggenheim Brothers by sticking pinholes in the paper cups at the water cooler. His colleagues never did discover who was responsible for the water dribbling down their neckties.

The daily summertime commute from Port Washington, Long Island, to New York City with his father-in-law—on a rather large yacht—put an added strain on a marriage that was already slipping. Dad simply did not fit into the businessman mold—nor did he share my mother's chief interest: horses. They were divorced when I was three, and my father was unknown to me until we met when I was twenty years old.

John Lawson-Johnston may never have met with much financial success, but it was hard not to admire his debonair countenance and manner, his knowledge of wines, and his attractiveness to women. In the end, he also proved to be admirably courageous. During World War II he served as a sergeant in the British Home Guard during the German bombings of London. Later, because of his dual citizenship, he served as a major in the U.S. Army. When the Americans entered Paris late in the war, Dad was asked by his commanding officer to obtain thirty filing cabinets for headquarters, he being the only staff member who spoke French fluently. His mastery of "business" terminology was sketchy, though, and the company was flabbergasted when Dad's request brought in thirty toilet seats.

A year after my parents' divorce, my mother married Freddy Wettach, a childhood sweetheart and an accomplished horseman. In 1927 he had set the unofficial world

record for the outdoor high-jump on a horse he had trained named King's Own. The jump—eight feet, three-and-a-half inches—beat the eight feet, two-inch record set by Heatherbloom in 1902. Though Freddy made his jump before eyewitnesses and a photographer, it occurred outside competition and was therefore not technically official. According to the Show Jumping Hall of Fame, however, it is "still generally acknowledged to be the highest anyone has ever jumped on horseback."

When Mom and Freddy married in 1929, Grandpa Solomon helped them buy a country home on Hope Road in Shrewsbury, New Jersey. The house, painted yellow with green shutters, was surrounded by fifty acres, which included a practice polo field, a huge, immaculately maintained stable, and an indoor riding ring. I am told that Grandpa, on his first visit, quipped that the stable was twice as big—and twice as nice—as the main house.

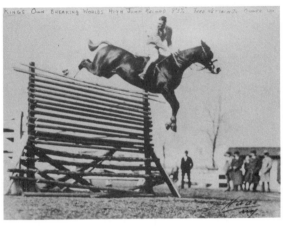

My stepfather, Freddy Wettach Jr., setting the unofficial world high-jump record on King's Own in 1927

About this time my childhood memories kick in. I vividly recall swimming at a very early age off the beach of The Towers, my grandfather's summer home in Seabright, New Jersey, and having to be rescued from drowning by a passing stranger. Mom was both embarrassed that his heroics were necessary and furious with me for my stupidity, which she expressed in a memorable spanking.

Indeed, Barbara was a strict disciplinarian, not averse to physical punishment. Once, when I tried, in a snit, to run away from Trillora Farm, she came after me on horseback with a bullwhip. While she took care not to make contact, she cracked the whip near enough to make "rounding me up" and returning me to the house a quick and simple task. Another time she caught me experimenting with cigarettes at the

29

back of our property. "Do you like to smoke?" she demanded? I gulped and answered, "Yeah." "Well, if you're going to smoke," she said, "then you're going to smoke properly." She made me inhale. "Do it harder!" she demanded. That killed my appetite for smoking for quite a while. As I grew older, my mother punished me by preventing me from enjoying specific events I had been looking forward to. The latter policy was far worse than the former practice.

In my physical appearance, and in certain behaviors that annoyed her, I reminded my mother of my father. I wasn't built the way she was, I didn't care much for horses, and I had trouble with simple household tasks, which made me seem helpless to her. (The latter complaint was somewhat disingenuous, as my mother always had household help, and she herself seldom cooked a meal or made a bed.) In any case, her feelings for me shuttled rapidly between love and something less. I don't recall any hugs, though hello and goodbye kisses were reasonably routine. She disdained emotional displays, perhaps as signs of weakness.

Whatever her motivations, my mother certainly deserves credit for my work ethic, my desire for meaningful accomplishment. In part because she meant to instill such virtues and in part because I was determined to prove myself—no matter what her expectations of me—my eventual capacity for leadership, such as it is, owes much to her firm hand.

My mother and Freddy Wettach had two children—Pamela, who died of pneumonia as an infant, and my half-brother, Michael. Not one to let something as mundane as pregnancy keep her from her avocation, Mom rode with Freddy in a "pair class" in a horse show at Madison Square Garden, during the first week of November 1932. She gave birth to Michael on November 24. My mother's perennial joke about this was that she and Freddy had fooled the show's officials, entering as a pair class when, with the unborn Michael, they really constituted a three-person "hunt team."

Our family moved around constantly, so Michael and I had few friends and were often alone together. Not that we felt sorry for ourselves; at some level we under-

stood that we led a privileged existence. We also got along well and engaged in some classic fraternal misadventures. When I was nine and Michael four, I decided we should put on a boxing match for the employees (who could not avoid attending) and neighbors of Trillora Farm. A "ring" was roped off in one of the barns and, after making sure everyone had paid admission, we fell to. Michael, much younger and much smaller, soon saw he was getting the worst of it and angrily tried to stomp

on my bare feet with his heavy shoes. This, plus my evasive efforts, amused the spectators, as I recall, but not Michael. The fight ended not in a draw but with him chasing me around the stable.

It is true that my mother had an easier relationship with Michael than with me. They shared a natural affinity for horses, and the two of them rode together almost daily. Michael later described their relationship as one of siblings, more than mother and son.

Our family lifestyle was surprisingly modest, at least in contrast to that of my grandparents, so it never occurred to me that my mother was rich. On the other hand, I

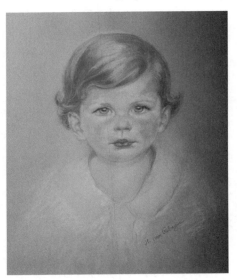

Hilla Rebay's portrait of me at age three (1930)

knew she wasn't poor. She was frugal about most things—obsessed, for example, with turning out unneeded lights in the house. She got that from Grandpa Solomon, who would always turn out the lights in every room as he made his way from the living room to the dining room—even though the Plaza was paying the electric bill. Like her parents, my mother ate like a bird, so there was seldom spare food about. I was never allowed in the kitchen anyway, which taught me at an early age not to eat between meals. Once, when I was about ten years old and away at Camp Bonny Dune for the summer, I swapped a sweater my mother had given me for a radio belonging to a boy named Andy Namm. I thought that was a hell of a good deal, but my mother berated me when I got home. And she made Andy send the sweater back.

31

A woman with little interest in clothing, jewelry, or other standard indices of wealth, she held herself in most cases to the penny-pinching standards she set for her sons. Michael used to recall one embarrassing time in the 1950s, when he and his California friends, Mo and Lillian Gallo, were visiting my mother at the family's South Carolina plantation. On a trip into the nearby hamlet of Walterboro, she drove them three times around the block looking for a parking meter that still had time on it. (The meter rate for an hour was a nickel.)

There were two exceptions to my mother's frugality. The first was flashy automobiles, including a front-wheel-drive Cord with some kind of bullhorn in the glove compartment. Driving through congested areas, she would broadcast pointed remarks at pedestrians, who wheeled frantically around, searching for their source. I vividly recall being with her when she tried to outrun a police car on Route 25-A, near Westbury, Long Island. Why she panicked, I'll never know. We were finally stopped in someone's driveway. She paid a heavy fine, as best I recollect.

The horsey set formed the other, grander exception to my mother's penny-pinching ways. She and Freddy followed the polo and horse-show circuit through four seasons. They wintered in Florida on Solomon's yacht, and in summer sailed to Europe on the *Berengaria, Europa,* and other ocean liners or made extended visits to Solomon's Railroad Ranch on the Snake River near Yellowstone Park in Idaho (which he co-owned with the New York Harriman family). Back home in Shrewsbury, they found time for fox hunting at the Monmouth County Hunt Club, with Freddy looking enormously dapper in pink coat with green collar, skin-tight riding boots, and top hat, and Barbara wearing traditional black hunting attire.

In their mid-twenties and on the social fast track, my mother and Freddy Wettach made annual pilgrimages to Miami Beach, where Freddy played polo with Stewart Iglehart, Pete Bostwick, Laddie Sanford, Fred Tejan, George Oliver, and many other well-known polo players of the day. I remember vividly the end of one polo match in Florida, when Freddy's pony collapsed just as he dismounted. It died on the spot of exhaustion, while Freddy wept like a child.

Freddy's system of training horses to jump ever higher was to have his assistants slap the underbelly of the horse with a bamboo pole as he and the horse hurdled the

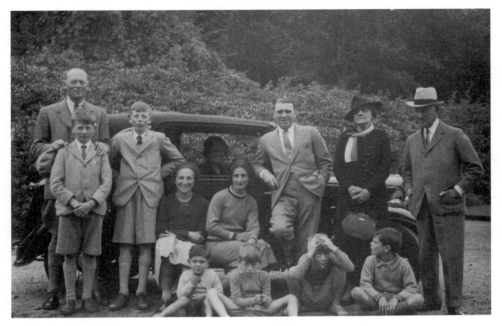

Three Guggenheim generations, August 1938, Sussex, England:
Top row (left to right): Lord Earl Castle-Stewart, his sons Robert and David Castle-
Stewart, Eleanor Castle-Stewart, Gertrude Guggenheim (in the car), Barbara Guggenheim (my mother), Freddy Wettach (my step-
father), Irene Guggenheim, Solomon Guggenheim
Bottom row: Michael Wettach (my half-brother), Simon Castle-Stewart, Patrick Castle-Stewart (sticking his
tongue out), and me

jump. Later he perfected this technique by wrapping a low voltage wire around the pole to shock the horse into remembering to leap higher next time.

One season in Miami Beach, Mom and Freddy began betting on horse races through a bookie. One day they won heavily, immediately bought a Rolls Royce that was parked on the street with a "for sale" sign on it, and drove wildly around Miami loudly proclaiming their good luck. The very next day, they bet it all on a "sure thing" and lost. When the bookie discovered they couldn't pay up, he threatened to tell the story to the Miami newspapers. Mom made good on the bet by hocking the pearl necklace her father had given her as a wedding present. Grandpa Solomon retrieved the necklace, but told her, "I bought them for you once. I'm not going to

buy them for you twice." He deducted the pawnbroker's fee from Mom's allowance for years afterward. From then on she rarely gambled, even on her own horses.

My mother and Freddy were happy together and, perhaps even more than she had than with my father, my mother felt free to live as she wished. Firmly ensconced in the upper class, with expensive habits such as horse riding, she nevertheless continued to avoid formal entertaining and spent little time with people of her own age and social standing. She had no patience for other women, and would just as soon drop dead as attend a "ladies' lunch." Instead, she socialized with people who worked on or near her horse farm or, as we grew older, with Michael and me and our friends. She liked earthy activities, like camping out, and she had no qualms about spicing up her conversation with an occasional, "Oh, shit!"

From the time I took my first pony ride at three until I was twenty and out from under my mother's rule, horses played a large, and largely unwelcome, part in my own life. My brother and I made our first public appearances in lead-line classes at local horse shows. In our early teens we competed in jumping events on hunters. I found horse shows incredibly boring: getting dressed to the nines, waiting endless hours for my class to be announced on the loudspeaker, competing, and then (if I'd not been eliminated) waiting again for the next opportunity. I particularly recall a pair of jodhpurs with some fifteen closely spaced buttons running down each calf, which could only be buttoned and unbuttoned with a buttonhook. Though I was complimented on my fine "boot leg," I detested all the dressing and undressing. A fox-hunting annoyance, which usually occurred at the wrong moment, was having to relieve oneself. Aside from having to find an appropriate spot away from other horsemen, one had to dismount from a bored horse, unbutton and button an over-buttoned fly, and finally remount. A high-class problem for sure, but one that must be experienced to be appreciated, particularly in freezing weather.

I was a reasonably good young horseman, and I might have enjoyed it more if I had ever had a horse of my own, for which I might have developed a real affection. I

did become somewhat attached to one horse, Qui Sait, which my mother had turned over to me because he seemed to sense and respond badly to her impatience. For some reason he suited me beautifully, which I think antagonized my mother, who soon afterward sold Qui Sait without my knowledge.

In 1986, when I owned a reasonably well-pedigreed mare, I decided, for old times' sake, to breed her to Ack Ack, my cousin Harry's famous sire. This union resulted in my owning a filly, Harry's Ack, which modestly commenced her racing career in the fall of 1989 under the watchful eye of my trainer, Bill Hirsch, grandson of the famous Max Hirsch. After Harry's Ack was claimed, since he was bred in Florida, each time the mare won a race for its new owner, much to my surprise and delight, a check was sent me by the Florida Racing Commission for 10 percent of the purse. It was nice to be compensated in this fashion without incurring any expenses. After forty years of avoiding meaningful involve-

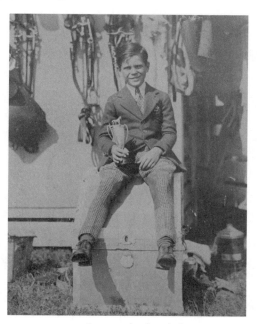

I seem to be pleased about winning a trophy in my least favorite sport

ment with horses, I briefly came around. After several years of my writing off losses at the track, however, the Internal Revenue Service took the position that my involvement in racing was a "hobby" rather than a "business." I quickly ended my flirtation with horses once and for all.

Barbara and Freddy were well-intentioned but deeply distracted parents, and our lives as high-class vagabonds made little sense to me. I had attended a minimum of

two schools a year since kindergarten—from Miami Beach to Pasadena to Sussex, England, to Port Washington, Long Island, to Shrewsbury, New Jersey—and had been tutored as well. And while I was crazy about Michael's father, who was in a very real sense my father, too, I sensed, even as a little boy, that Freddy Wettach had a drinking problem. I spent interminable hours with him in bars and saw him hide bottles of whiskey in his riding boots and other nooks and crannies. Freddy's drinking problem finally became acute and my mother, a teetotaler, grew less and less enthusiastic about their relationship. She spent six weeks at Grandpa's ranch getting the divorce that ended their eight-year marriage. "Guggenheim Heiress Unhitches Horseman," crowed the *New York Daily News*, taking perverse delight in the fact that my mother had obtained her divorce decree while Freddy was in the hospital with bronchial pneumonia.

I was eleven and Michael was six. As part of the divorce arrangement, Michael spent several weeks a year with his father in Red Bank, New Jersey. Mom would supply Michael with money to ensure that he ate properly while visiting Freddy. Freddy would, in turn, take Michael to a diner in nearby Eatontown, then leave Michael at home and go off to the bars with one of his many girlfriends . . . and Michael's "lunch money."

At least once in their post-marriage parenthood, my mother and Freddy allowed poor Michael to fall through the cracks. He was at Friends Academy in Locust Valley, Long Island, on the last day of winter term. Classes ended, and all his schoolmates left for vacation. Though he stood at the end of the school driveway until dark, nobody came for Michael. The school had no boarding accommodations, so he spent the night in the school infirmary. Word somehow reached our Scottish nurse Jean Peat, who finally came and rescued him. Michael still has a postcard he wrote to our mother (addressed to her at "General Delivery, Miami") saying, "What should I do? Everybody's left school and I'm here alone!"

For thirty years after my mother divorced him, Freddy Wettach continued to drink. He spent days on end at the "21" Club, drinking rum and lime juice beneath a picture of himself on King's Own making that record-breaking 1927 outdoor high-jump. Once, when I was married and living in Princeton, I received an emer-

gency phone call from my mother. "Freddy's stuck at the Plaza. Would you go and get him?" When I arrived, I discovered why Freddy was stuck—his ankles were so swollen from drink he couldn't get his shoes on. His guest, a lady friend from Charlottesville, Virginia, had left him there, along with the hotel bill. I brought him back to Princeton and put him in the hospital.

The winter after Freddy and Mom divorced, Michael and I were surprised to find that the small, open-top boat my mother docked next to our Miami Beach house had acquired a "captain." We were even more surprised to discover that this captain was the same he-man, Henry Obre, we had known casually back in New Jersey. Henry owned the Tydol gas station in Shrewsbury, next to the public school we briefly attended there. Seeing Henry in his new, nautical incarnation, I recalled that Mom and I had often stopped at the gas station when her relationship with Freddy was going bad. Henry was a very handsome guy whom Mom had clearly noticed, and he was taken by her because she drove the horse van, a task few women in those days would do.

One day at Henry's gas station, with Mom flirting and he responding in his John Wayne fashion, it flashed through my mind that my own identity—and stability—were at stake. When I was only three and had no voice in the matter, Mom had adopted Freddy Wettach's last name for me. She seldom mentioned my father except when admonishing me for some misdeed that was "just like him," thus increasing my absentee affection. Now eleven years old, I sensed the warmth of this new relationship and the likelihood that Mom would soon marry Henry. Indeed, Henry and my mother were soon engaged, and Henry swapped the title of "ship captain" for senior vice president of the Grinding Wheel Company. Grinding Wheel's president, Ed Best, was a friend of Henry's who gave him the title (though not the job) as a favor. As her union with Henry Obre drew near, Mom, in one of her good moods, asked if I would like to have my original Lawson-Johnston name back. Fearing another name change, I quickly said yes.

Many years later I discovered the reason for my mother's offer. After my father's death, Michael discovered among my mother's belongings a letter my father had sent her after her divorce from Freddy—a letter she had never shown me:

My dear Barbara —

Your [second] divorce surprised me. I suppose mine did not. For the first time in years I am free and intend to remain so.

Don't you think Peter and I should get to know each other better?

I should hate to think that when he grows up he would feel that I had made no effort to see him. Up to now it has been the force of circumstances that I have not pressed the point of seeing him because you were married and I did not wish to intrude. However now you are free and I see no reason for me not to seek the opportunity to see you and our son. I do hope you will come over to England in the near future.

Now that we are older and wiser in many things you will agree that as we are now both free and we have this great bond and mutual interest in Peter, who will soon be a man, there is no reason why we should not be the greatest of friends. I do repeat again Barbara that I do not want Peter to grow up feeling that I have never taken an interest in his life. As one grows older one feels things more keenly.

I hope you are both well. Do drop me a line to above address where I am now living.

Affectionately,
John

I was not to meet my father for another decade.

Barbara and Henry Obre slipped out to Darien, Connecticut, to get married in 1939. When the news broke afterward, the *New York Mirror* carried the story. "For the second time the copper heiress, the former Barbara Guggenheim, has jolted society

with an elopement—this time with Henri [sic] Obre, her chauffeur, who also took care of her boats at her Shrewsbury, N.J., estate." That particular article went on to quote Freddy as saying their divorce was not yet final, though in fact it had been so for months.

My brother and I accompanied the newlyweds on a lengthy honeymoon in Pasadena, California, where they rented a house and I attended Polytechnic Junior High School. Mom was madly in love with Henry Obre and did everything to please him. She deferred to Henry on most things. Her "Henry sayses" made us boys ill, principally because we weren't used to thinking of her as being submissive to anyone.

Mom and her third husband, Henry Obre, in the early 1940s

Michael and I disliked Henry as much as Mom adored him. "Henry knows too much for one and not enough for two," Michael's father aptly put it. And while his affection for his own opinions earned Henry little respect among his peers, we boys were always wrong until proven right. My mother was the only one to discipline us, but more and more often her excuse for doing so was, "Henry says . . ." Disoriented and upset, I made a half-hearted attempt to run away, found myself locked out of the house upon my return, and had to scramble up a wisteria vine to climb into my bedroom window.

The September after my mother's third marriage I was bundled off to boarding school. There, against all my expectations, I finally encountered the reliably consistent care and guidance most children enjoy. The Lawrenceville School near Princeton, New Jersey, saved me. Whatever ambition, stability, and good judgment I carried into adulthood I owe to a few Lawrenceville teachers and older students.

I arrived at Lawrenceville in 1939 as a twelve-year-old seventh-grader—a skinny, shy boy with innate common sense but not much self-confidence, particularly about studies. As a "Rhinie" (Lawrenceville's term for a new boy), I put up with some mild hazing from older students. And we all lived in respectful fear of Spencer Hackett, the teacher in charge of all seventh and eighth graders, who was famous for his "triple-clip," three quick whacks to the back of the head with the big ring on his right hand.

Things improved as I moved up the school's ladder. I spent my sophomore and junior years in a dormitory called the Dickinson House, whose resident faculty director, Ted Keller, became a surrogate for my father, whom I did not then know. Ted's wife, Nan, stepped in for my mother, who was preoccupied with her new husband and my younger brother. I also found role models in the seniors who led the student body. Under the spell of hero-worship, I semiconsciously developed a game plan for my Lawrenceville career: to be school president. Knowing academics would be a struggle, I determined to excel in a sport, command respect, enter into extracurricular activities, and remember the names of all my fellow students (the latter skill has declined over the years). My strategy soon bore fruit. I was elected president of Dickinson House and captain of the varsity wrestling team and was named School Bearer of the Cross.

But overhanging these successes was a cloud of fear that someone at the deeply WASP-ish Lawrenceville would discover I was half Jewish. My religious heritage was actually more tangled than that, as my mother had converted from Judaism to Christianity. Educated at home by a tutor until she was sixteen, she had been sent away to St. Mary's Episcopal School in Peekskill, New York, where she became an Episcopalian. This was no earth-shattering conversion. As I've noted, I never recalled my grandparents discussing their religion or (until my grandfather's funeral) entering a synagogue. I am reasonably confident they weren't hiding their Judaism, as their economic status insulated them at least from overt anti-Semitism. Instead, I believe they were simply indifferent.

If anything, my mother was more indifferent still. Though she sporadically attended Episcopal services and was eventually buried in St. John's Church cemetery

near her Maryland home, she had a hard time taking her adopted religion seriously. Calling on her one day, the St. John's rector found Barbara in her bathing suit, washing her car. She told him her family was Jewish, but that she had converted to Episcopalianism in high school and that her first husband had been an Episcopalian, her second a Catholic, and her third a Presbyterian. "Madam," he said, "what I have learned about you this half hour should have taken me three visits."

Once, when I was about nine and recovering from a tonsillectomy, my mother told me to tell the hospital chaplain I was an Episcopalian. When I protested that the term was too hard to remember, she replied that I need only remember "piss in a pail."

In any case, I was as a child completely unaware of my Jewish roots. In fact, as with so many non-Jews of my American generation, I was ignorant about Judaism itself, beyond a vague notion of its exotic unfamiliarity. Then, a few months before I entered Lawrenceville, my nurse, Jean Peat, stunned me by saying, "If Hitler wins the war and takes over the United States, you will be killed because your mother is Jewish." From that moment through most of my high school years, my heritage became rather an obsession. The reader should understand that there actually was anti-Semitism at Lawrenceville, as at many private schools in those days. I recall several instances of petty prejudice, which confirmed my determination not to advertise a part of my identity.

Despite my fears of being "unmasked," I achieved my goal and in my senior year was voted school president and "Best All-Round Fellow." I also ended up at the bottom rung of the scholastic ladder. A final grade of thirty-six in chemistry provoked a full meeting of the Lawrenceville faculty to discuss my case. Whether the vote to let me graduate was close or not I will never know, but I did receive my diploma. In the years since, I have served Lawrenceville in as many ways as possible. In 1990 I was elected president of the school's board of trustees, a position I held for seven years and an honor that has meant more to me than any other.

The nurturing stability of my Lawrenceville experience stood in stark contrast to life on the home front. While Henry Obre wasn't a continuous drinker like Freddy Wettach, he was a sloppy drunk. Usually his "in-cups" behavior was simply embarrassing (he was a great pincher of women at dinner parties). There was one terrible incident, however. I was fourteen, sitting with Michael in the back seat of the car on our way to the ranch from West Yellowstone. Henry was drunk and driving badly. My mother leaned over from the passenger seat to switch off the ignition, and the next thing I knew he was slugging her. I reached over and pinned his arms behind him, and he stopped. He never said a word about it afterwards.

Back from California, my mother and stepfather rented a house from Harvey Ladew, a legendary horseman, on Hegeman's Lane in Brookville, Long Island. Several years later they moved on to My Lady's Manor in Maryland, an area north of Baltimore where the chief activity was fox hunting and where my mother had purchased Andor Farm. The original structure was some 250 years old. Though its rooms were large and its ceilings remarkably high, Andor Farm boasted but three bedrooms. Henry and my mother took one and Henry commandeered another as his dressing room, so Michael and I bunked together in the third.

When we moved to Andor Farm, Henry's idea was to be a gentleman farmer. My mother surprised Henry with a pair of Clydesdale horses to be used for plowing and other chores. Their feet were so big they trampled down the crops, so she bought him a huge John Deere tractor (even more useless for the purposes he had in mind). Henry really did not appreciate these surprises, being rather proud and fearful of becoming a "kept man," but it hurt Mom's feelings that he was so ungrateful. To make him feel more secure, she put Andor Farm in his name and thereafter referred to "our" farm, while he said "my" farm.

The allure of farming waned quickly, and Henry decided to go into the pond-building business. "I want a bulldozer," he told my mother. "Oh, I'm so glad you want *something*," she replied, and immediately bought him one. Henry and his friend, Hugh Wiley, dug about eight ponds for people around the neighborhood.

Then Henry, deciding he wanted to be in the lime and fertilizer business, set up shop in an old mill, most of which he stored his product in and a small portion of

which he made into his office. He hired a secretary, and pretty soon my mother became suspicious about his relationship with this very young woman. Mom confronted Henry, who responded by refusing to utter a single word to her for several months. And long months they were! I remember sitting through endless breakfasts as my mother poured coffee and prattled on, while my stepfather simply never answered her. Mom, in turn, became obsessed with her suspicion—which proved valid—that Henry was having an affair. She would sneak over to the mill and peek in the windows.

At one point my mother hired a detective to spy on my stepfather. One night, having been told by the detective that Henry and his lover were dining with one another, Mom locked Henry out of the house. When he came home, drunk, and realized he couldn't get inside, he began pounding on the front door, and then on the windows, until my mother decided to let him in before he broke one. Henry lurched into the foyer, smacked her in the face, blackening one of her eyes, and yanked at her necklace until it snapped, scattering pearls over the floor. She was able to break away from him and call the police, who put him in jail for the night. Jane Bassett, a friend and neighbor, bailed him out the following morning. As with the driving incident in Idaho, Henry spoke not a word about this event afterward, and when pressed would simply say he'd been too inebriated to remember anything about it.

Henry's lover had a son who was away at school in Pittsburgh. One night my mother drove from Andor all the way through Pennsylvania into the hills of Pittsburgh's mining section to find this boy (who was all of fourteen at the time), wake him up, and tell him his mother was a whore who was ruining her marriage. The boy was, of course, much too young to be told any of this. It was not my mother's finest moment.

As difficult as the marriage was, my mother stuck it out, from 1939 when she married Henry Obre until he died in 1970. Eventually, they reached some sort of stalemate. The secretary moved away. Henry came slinking back, but by then Mom had transferred most of her activities to a commercial breeding farm down the road from Andor, which Michael—now grown up—was directing. She liked her horse trainer Kenny Field—a good friend of Michael's—and the farm manager, a family friend named Betty Miller. For years, according to Michael, she'd be at the horse farm at the crack of dawn and stay until after dark.

Henry Obre's death was, frankly, a relief to us all. As my mother's sister Eleanor once told me, "The one thing about my sister I'll never understand is how she can lower herself to put up with Henry." The simple answer is that she was determined to not be a three-time loser. She never married again, though not long after Henry died, Freddy Wettach, sober at long last, reentered her life as an old, dear friend. He would visit my mother quite frequently, often spending a month in Maryland with Michael and regularly attending dinner parties at my mother's as her "date."

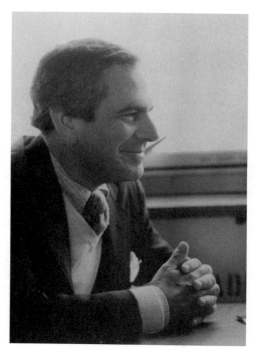

My half-brother, Michael Wettach, in 1981

For his part, Michael carried on the best of our mother's equine tradition. He did spend a few years as a young man in New York City, where he worked as assistant to the acclaimed composer and lyricist Jule Styne, whose Broadway hits included *Gentlemen Prefer Blondes*, *Gypsy*, *Peter Pan*, and *Funny Girl*. Besides serving as stage manager for the 1956 Broadway musical *Mr. Wonderful*, Michael once served as Ethel Merman's driver. By his own estimation, Michael's nearest claim to fame during his New York sojourn was his minor hand in Jayne Mansfield's "discovery." One night, when he was working as a casting director for a Broadway agency, some producer flew into his cramped Eighth Avenue office crying for a "Marilyn Monroe type." Michael flipped through an in-box full of photos, pulled out Mansfield's, and handed it to the harried customer. The rest, as Michael said, was history.

Soon afterwards, Michael moved back to Maryland, where for many years he managed my mother's breeding farm in Long Green Valley. He also restored an

eighteenth-century building into "The Admiral's Cup," a popular restaurant in the Fells Point section of Baltimore. I'm fairly certain, though, that Michael didn't find true happiness until much later in life. Michael was gay, and in our generation being gay was vastly more problematic than being Jewish. Though he and I never discussed this part of his life, it was clear to me that the relationship he formed in the 1980s with a man named Robert Ludwig was a major turning point for Michael. Bob moved to Andor Farm in the 1980s, and my family and I grew very fond of him.

In May 1999 Michael's doctors found evidence of heart disease and scheduled him for exploratory surgery. Early one Saturday morning, four days before he was scheduled to undergo this procedure, I received an emergency-room call telling me that Michael had been admitted after having suffered a heart attack. I rushed down to Maryland but arrived an hour too late. Only sixty-six years old, Michael lay dead in a hospital bed, Bob Ludwig by his side.

Her serial marriages notwithstanding, my mother seemed to weather all of them well. As with most things, her attitude toward marriage was eminently practical. "I always had somebody lined up before I got rid of the one I was married to," was her official line. And she seemed, in the end, to make peace with her first two husbands. She was quite comfortable with my father by the time I met him, and she even approved of his wife, Paulette. Indeed, she used to visit my father and Paulette in New York when she was still married to Henry, which must have been a delightful break for her.

Like most Guggenheims, my mother was nothing if not public spirited. Her philanthropy, though, was primarily limited to individuals whom she helped in one way or another without letting it be known. She had great empathy for less fortunate people—if their personalities appealed to her. This was true of dogs, as well: she was never without one, and they all had interesting personalities. During World War II, she served at Long Island's Mitchell Field Hospital as a nurses' aide volunteer. While most of the nurses lined up for duty serving GIs my mother worked in the infants'

ward of Nassau County Hospital because she was told that was where they needed aides most. She also served in the Motor Corps and claimed she could back up a car in the dark more quickly than anybody else.

Barbara Guggenheim was a liberated woman—at least she did exactly as she pleased all her life, until her disabling stroke. She dominated everyone around her except Henry Obre, whom she didn't even succeed in pleasing much despite strenuous efforts. In today's climate for women she would not seem or feel out of place. I cannot see her pursuing a career, though, even if she had gone to college after graduating from St. Mary's School. Business bored her.

Like so many people in her world, she seemed to care most about horses. When she finally stopped competing in horse shows and fox hunting, she became engrossed in steeplechase racing—not as a rider but as an owner. Ultimately she got into flat racing and enjoyed a modicum of success, but she never matched her cousin Harry Guggenheim's record with racehorses. As an older woman, her life revolved around her trainer, Kenny Field, and her racehorses. She spent nearly every fall at her South Carolina plantation, Big Survey, where the horses were conditioned for competition at the Florida tracks, then taken back north to run in Maryland, New Jersey, and New York. A house was rented at Saratoga in August for her to watch her stable compete with the elite.

On balance, I think my mother led an enjoyable, reasonably fulfilling life. She was an avid reader, loved to travel, and enjoyed her friends. Her candor and her laughter were so contagious most people enjoyed talking with her. I know I always did—at least when the topic was not my misbehavior. Having perhaps learned from her first two husbands that drinking creates problems, she abstained until later years, when she would have an occasional cocktail.

My mother's self-absorption clearly cost her sons. In retrospect, aspects of my childhood seem practically Dickensian. I suppose I have a right to be angry about parenting that by today's standards would be deemed neglectful and occasionally abusive. Indeed, there are things for which I'll never forgive Henry Obre. But as I began to emerge from my "poor little rich" boyhood, I realized I loved my mother and for the most part enjoyed my relationship with her, the more so as we both grew

older. Our personalities, some of our values—and most of our interests—were vastly different, but I adored her nonetheless. Life with her may have been hectic, but it was never, ever dull.

In 1945, at the age of eighteen, I began my second—perhaps more important—education. Two weeks after graduation, having been drafted at Lawrenceville, I reported to Fort Dix, New Jersey, for induction into the U.S. Army. Though I had never considered myself spoiled, life in the service came as a rude shock. Having one's head shaved to near baldness; the incessant, incomprehensible, nitpicking orders; the ill-fitting, unpressed clothes and uniforms; the lack of privacy for one's toilet; and the total lack of freedom all served to humble me (which I guess was the purpose) and irritate me no end.

At Fort McClelland, Alabama, during my seventeen weeks of basic infantry training, I formed no close friendships but got on pretty well with my fellow boot campers as we suffered the misery together. My hyphenated last name caused a complication: every soldier in basic training owned a helmet liner with his last name emblazoned on the front so that the sergeant could identify the recruit readily. My name circled my entire helmet, so I responded to almost any familiar syllable. Needless to say, I did not advertise or even disclose my Guggenheim ancestry. Friends with Jewish names reported that anti-Semitism was alive and well among the troops mobilized to fight Hitler.

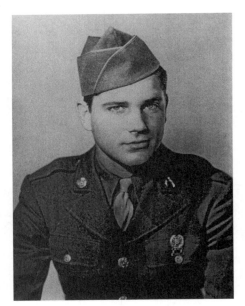

Soon after completing my Army infantry basic training, 1945

47

After basic training I shipped out to Italy. Of the 10,000 troops who landed in Naples, I was one of twenty-five chosen for desk jobs in Rome. The reader might fairly wonder (as did I) whether some well-connected family friend had engineered my selection. Apparently, though, these assignments were based on IQ test results (meaning my poor academic performance at Lawrenceville was probably a case of underachievement). In any case, I ended up as a clerk in the luxurious Excelsior Hotel, where the army billeted generals, colonels, and majors, as well as USO stars and high-level diplomats.

My timing was good: someone had just tried to throw a prostitute out of an upper-story window of the Excelsior, creating a scandal as well as a policy not to allow women other than wives of officers above the ground floor. My commanding officer immediately assigned me to enforce this new policy. I posted MPs on all the elevators and stairways—and soon discovered my security system was leaking like a sieve. It took me ten days to discover the girls were going up from the kitchen on the dumbwaiter. My ultimate success pleased Captain Newton but not many of the officers living there.

Near the end of my year at the Excelsior I fell in love, I thought, with a charming girl from a nice local family: Mury Lucchesi, half Egyptian, half Italian. But our romance began to scare me when the U.S. commanding general in Rome invited me to spend an additional year in the Excelsior and go from sergeant to second lieutenant. It turned out that Mury's father knew the general and had arranged this. Worried that I might become an alcoholic in that bacchanalian atmosphere, and innately fearful of marriage, I turned down the general's generous offer. When Mury came to the States six months after my return, the magic had dissipated for both of us and I never regretted my decision. Years later I learned that love letters from Mury soon after I left Italy were intercepted by my mother, who was not the least bit enthusiastic about my becoming entangled with someone she didn't know or approve of.

Months after my return to the States, at the age of twenty, I met my natural father for the first time since I was three years old. Planning for this meeting had begun about a year earlier, at the Excelsior Hotel. Lawrence Tibbett, the opera star, had checked into the hotel one day with a message for me: "Your father, whom I've just left in Paris, is most eager to see you." Thrilled at this first evidence that Dad had any interest in me, I grilled Mr. Tibbett for details about him. "He is very sensitive as far as you are concerned, Peter, about his having married so frequently."

So on a spring day in 1947, sitting on an overstuffed settee in the Plaza Hotel's Palm Court (remarkable how much of my family's business was carried out in that place), I saw a man about my father's age seated nearby. Since he kept glancing at his watch and eyeing all the people in the vicinity, I finally got up the nerve to ask him if he was waiting for somebody. "None of your damned business," he replied, then stalked away.

As I was recovering from this bizarre encounter, I noticed another man pacing back and forth under the Palm Court clock and knew for certain he was the father I'd been waiting to meet for my entire life. He was about forty-five and greatly resembled the actor Douglas Fairbanks Jr., with a full head of gray hair, a moustache, "bedroom blue" eyes and a British bearing, hands clasped behind his back as he looked about for his son. I wondered how to address him. "Dad?" "Father?" "Sir?" What would we say to each other? How was I to broach the delicate subjects of his five wives and his seventeen-year failure to seek me out?

I stood up. We approached one another, too reserved to embrace. "Hi, Dad," I said. We shook hands. "Peter!" he exclaimed. "By Jove, you've grown!"

"Yes, I've grown—old enough to join you for a drink in the Oak Bar."

The first scotch-and-soda carried us over the many missing years in our relationship and—inexplicably—I felt I loved him as much as any son could love his father. I was also emboldened to inquire (most tactfully, as Lawrence Tibbett had advised me) as to his new marriage. He seemed relieved that I'd asked, and soon after our reunion, I met my father's fifth wife, Paulette, a beautiful Parisienne. She was only a few years older than I, so it was not easy to think of her as my stepmother, but she was wonderfully helpful to Dad and me in bridging our seventeen-year gap.

I wrote the following letter to my mother soon after the reunion with Dad, an event I soft-pedaled to spare her feelings:

Tuesday

Dear Mom,

The weekend was really O.K. in as much as I got to know Paulette and "Dad" pretty well.

As you say—after you went through the unpleasant business of raising me he wants to enjoy the result—or am I flattering myself?

Anyway I asked them down for the weekend of the fifth and they might do it.

I had to laugh when he said that you'd said I had his traits—he wondered how you meant it. . . .

After the army, I looked upon college life as a somewhat juvenile experience that had to be endured if I were to realize my ambition to be a success. Having been admitted both to Princeton and the University of Virginia, I chose the latter because I could begin my studies in February, rather than wait till the following fall.

Money was an immediate worry, as the following letter to my mother attests:

Have gotten around to sending you an estimate of what it costs me to lead an average existence here. My flings are excluded, and depending on how generous you feel, I could stand anywhere from $75.00 to $90.00 from you plus the $75.00 from the gov't. I know this sounds mercenary as hell, but it can't be helped.

I feel like Daddy ["Daddy" in this case referring to Freddy Wettach] asking for money but I haven't got much choice. You must feel like quite a money bags supporting all us bums—

Love, P.wee

One Month Necessities

Meals at fraternity	
(twice a day except Sat. & Sun.)	$ 50.00
Meals at home and out	$ 18.00
Cleaning and pressing	$ 6.00
Fraternity dues and assessments	$ 14.00
Rent	$ 32.50
Electricity for apartment	$ 1.50
Odds and ends (toothpaste, etc.)	$ 2.00
Total	$124.00

Pleasure (?)

Car (oil, gas, etc.)	$ 20.00
Movies	$ 4.00
Club (1 meal wk.)	$ 10.00
Cigarettes	$ 7.00
Total	$ 41.00

I spend about $165.00 per month and that doesn't count or include dates, such things as going to Princeton on a big weekend, etc.

Harold [my roommate] gets $100.00 a month from home + the $75. gov't. check but has to buy his clothes out of that.

It may not look it but I've been conservative in my estimates. . . .

One concern I had in seeking to join a fraternity was the possibility that I might be blackballed because I was half-Jewish. St. Elmo, the fraternity I pledged, was considered somewhat stuffy; I doubted it had ever had a Jewish member. The brothers knew that my mother was a Guggenheim because my roommate, Harold Xanders, knew her from Baltimore. I don't know how much deliberation took place before the brothers decided to "rush" me but have always presumed my best friend Harold made it known that this should not be a factor.

A letter to my mother during rush week reveals (indirectly) my anxiety:

[T]he idea of going to see the "frats" is for them to get to know you and vice versa. Everyone is on their best behavior, makes a lot of small talk with you, for a half hour, then you go to the next place on your schedule. If one man in a house doesn't like you (the way you part your hair is ample reason), he says so (after you've gone) and then you get a notice not to bother coming back.

I've made up my mind to go to St. Elmo, but just in case one guy "black balls" me, I've got two other houses lined up.

Read in *The Sun* that you and Henry "had lunch"—fine!

Love, Peter

During my premarital college years, my mother reasserted her authority, making certain all my time was usefully spent. One summer I worked as a night clerk in the Admiral Hotel in Cape May, New Jersey. Another summer, I drove myself to New Mexico to work as a roustabout for the oil company American Republic. Not only was the work tough physically but the social life was nil, living in a rented bedroom in a family's small house. The experience taught me I was not cut out for hard labor. My fellow roustabouts shot craps during lunch hour, and for some reason I did well at this. All went well until "Cap" Rieber, chairman of America's parent company, visited the property, landed in his private plane, and asked our foreman where Peter Lawson-Johnston was. My fellow employees had not known I got my job through the chairman in New York City. I'd told them that I was simply "passing through town." Fortunately, we were all on good terms by then and no one seemed seriously put out.

Perhaps because I survived this particular social unmasking unscathed, and because my college friendships were deep and secure, I finally began to shed my self-consciousness about my Jewish roots. Soon this was supplanted by pride. Over the past fifty years I have considered myself fortunate to have both Jewish and Episcopalian ancestors.

Back in Charlottesville that fall, I made the mistake of falling in love with my best friend's date—a brilliant mistake, as it turned out. Dorothy ("Dede") Hammond was several years younger than I, beautiful, a bit of a flirt, and enormously popular. She was also a Baltimore debutante in the midst of a social flurry that surrounded

her "coming out." Frustrated by the competition, I finally took her aside and said that I intended to date her regularly—once all the hubbub subsided. My hope was that her interest would be piqued by my maturity and independence. It was not easy to stand aside for those interminable months while others rushed her off her feet, but I stuck to my game plan and it worked.

One fall Saturday in 1948, we were alone together in a mutual friend's living room in Philadelphia when I told Dede I was madly in love and hoped she would marry me. The moment she said yes was the high point of my life, before or since. In more than half a century together, our love for each other has only grown. We have also raised four children—Wendy, born in 1952; Tania, born in 1954; Peter, born in 1957; and Mimi, born in 1967—all of whom have played their parts in the Guggenheim legacy, not least by bearing us ten grandchildren.

My mother's approval meant a lot to me, of course. She questioned my ability to support a wife, and our engagement extended to well over a year. We were married September 30, 1950, in St. Thomas' Church in Garrison, Maryland. Dede's parents held the reception under a huge tent at their home nearby. Rosa Ponsell, the opera star,

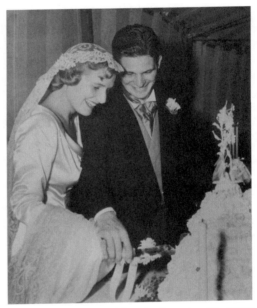

Dede and I cut the cake, September 30, 1950

sang. I vividly recall her heaving bosom as she stood between Dede and me singing "Some Enchanted Evening." Aside from my mother and stepfather, Henry Obre, and my brother Michael, no other members of my family attended except a distant second cousin, Percy Lawson-Johnston, the sole representative from my father's side of the family. Even though Dad and I had grown close, he was in Switzerland and not encouraged by my mother to attend.

53

In the ensuing years Dede and I made family amends in our own way, frolicking with Paulette and Dad in London, Paris, Barbados, and Lausanne (where he lived the last twenty-five years of his life). We once spent a week with them in Cannes, driving about in Dad's 1929 Rolls Royce, drinking and dining together, having an absolute ball. Each night Dad and Dede, in the front seat, and Paulette and I, in the back seat, kissed goodnight before he dropped us off at the Carlton Hotel. And each night the farewells became a bit lengthier. Finally, one morning at brunch Paulette announced, "This prolonged kissing we must terminate." Our agreement was instantaneous.

Dad and I never had a serious disagreement during this period. Whatever shortcomings he may have had—his low resistance to drink and gambling, for instance—Dede and I accepted, knowing we couldn't reform him. Much as I liked him, I was never tempted to take my father as a role model.

Dad had one other child, Orma, by one of his later marriages, whom I met after getting to know him. She was sometimes fun to be with but had quite a few personal problems, which she blamed on Dad, and she seemed, not surprisingly, to enjoy shocking and humiliating him because he had neglected her as a child as well. Dad seldom spoke of her, and I seldom saw her. She died of cancer at a rather young age, which I was unaware of until several years later.

Though it is difficult to define an alcoholic, it is equally difficult to believe that Dad was not one, though it never affected his speech or physical balance, nor did it make him disagreeable. Once, when I drove Paulette and him from Pully, Switzerland, to Paris at breakneck speed because I had a business appointment, he was annoyed at my refusal to stop at a "watering spot" along the highway so he could have a drink. That was about as disagreeable as he got.

John Lawson-Johnston died in 1975. Paulette herself eventually became a genuine alcoholic whose embarrassing deportment made a teetotaler of my daughter Wendy. Paulette died in Lausanne several years after my father's death. I attended her funeral and arranged to have her ashes interred alongside Dad's in the Dunlap mausoleum at Woodlawn Cemetery in New York City.

After a few days' honeymooning in Bermuda, Dede and I returned to Charlottesville for my last term at UVa., setting up house in a tiny cabin on an estate outside of town. I had chosen to major in philosophy, in part because it seemed more glamorous than economics or accounting, and in part because I still lacked academic confidence and figured philosophy would be easier to bluff my way through.

In the end, a course in logic had the most lasting effect on me. Having been politically liberal in high school, and apolitically patriotic in the army, I found myself growing more conservative under logic's influence. Within the relentless discipline of rational discourse, it gradually dawned on me that much of what *feels* right about liberalism may not in the end *be* right, even for those people liberals sincerely intend to help. I still believe this to be the case. Though my perspective is shared by few of my colleagues in the art world, it has never compromised my relationships with them—principally because those relationships have nothing to do with political inclinations. A healthy wariness about uninformed good intentions, however, is a sensible attitude for somebody trying to manage any multimillion-dollar enterprise, even a nonprofit one such as a museum.

On my graduation, Dede and I rented a house outside Baltimore, and I landed a job at $35 a week as a cub reporter for the *Baltimore Sun*. I foresaw a glamorous future in this role, but after several months of phoning in my stories to rewrite man Russell Baker I began to wonder if I was getting anywhere. Russ Baker was very bright—and bored stiff. To divert himself, he would sometimes take a piece by me and make my hero look like a jerk. He went on to become the renowned, acerbic *New York Times* columnist, author of the bestselling autobiography *Growing Up*, and host of *Masterpiece Theater*. In a 1989 letter to me, he wrote that my toil as a police reporter seemed "such an unlikely, absurd beginning for someone destined to become what the press loves to call a 'mover and shaker.'"

One afternoon I reported to work as usual and was called into editor Buck Dorsey's office. Did I know anything about boats? "No." "O.K., from now on you're yachting editor." So I spent my weekends covering sailing races on Chesapeake Bay, an assignment I found less than engrossing. Nor was the yachting fraternity impressed with me: on my first assignment, awaiting the finish of a race aboard the

committee boat, I asked (to audible gasps) how one got "downstairs to the bathroom" instead of "below to the head."

But what really ended my career in journalism was trying to live on $35 a week. I left the *Sun* to become executive director of the Maryland Classified Employees Association, a state employees' union. I published their magazine, traveled the state visiting chapters, and tried to increase membership. With the pro bono guidance of my new father-in-law, Donald Hammond, a top fundraising professional based in Baltimore, I increased the association's membership by about 25 percent. I was emboldened to ask for a substantial raise, was turned down, and quit.

Next I became public information officer of the Maryland Civil Defense Agency. The job was easy and paid well, but helping state officials develop essentially futile plans for surviving a nuclear attack soon seemed a pointless exercise. Neither this job, nor (in hindsight) my job with the Classified Employees Association deeply engaged me. I seemed to be working solely to maintain a respectable lifestyle rather than to accomplish something that mattered. I began spending too much time at the country club with my still-single male friends and drifted from general restlessness to something approaching self-disgust.

For the first time, I began to wonder if there was a place for me somewhere in the Guggenheim orbit. I asked my mother if she knew somebody at Guggenheim Brothers who might give me a chance to prove myself. She suggested I visit Albert Thiele, her father's executor and director of various trusts set up by Solomon. A cool, correct man, conservative in every way, Mr. Thiele had risen from Solomon Guggenheim's accountant to his replacement on some corporate boards. Though he intimidated me, he was receptive to my request—perhaps because I told him I would happily start at the bottom for half my present salary to get into something with a future.

Mr. Thiele was also chairman of a tin-mining company, Pacific Tin Consolidated Corporation, started by my grandfather in the Yukon at the turn of the century. Pacific had recently acquired a feldspar mining company headquartered in Spruce Pine, North Carolina. (Feldspar is a fluxing agent used by the glass and ceramic industry.) I jumped at the chance to go to that beautiful mountain community just northeast of Asheville. By now, I was about thirty and felt I must start moving up.

Since no one at the home office knew much about feldspar, this was a great chance to become Pacific Tin's feldspar "expert." I was ecstatic, though it would be a financial strain, since we already had two daughters, Wendy and Tania, and Peter on the way.

I went to Spruce Pine alone, leaving Dede, eight months pregnant, with the children at home outside Baltimore. They would all join me after the baby was born. It would be hard to leave our many friends, but we both knew it was the right decision.

To be honest, I entered the Spruce Pine assignment with an attitude of "doing time in the hinterlands" while awaiting the call to higher service. And it is true that in social background and education I was somewhat more sophisticated than some of my coworkers. But my new boss, Carroll Rogers, who had stayed on to manage Feldspar Corporation after his family sold out to Pacific Tin, was a great and kind teacher. A hard-working, caring man who seemed genuinely to welcome my arrival, Carroll gave me a crash course in the feldspar business. He put me to work in various plant quality-control laboratories and took me along on sales trips to our glass and ceramic customers, as well as to our various mines.

About six months after arriving in Spruce Pine, I became sales manager for a staff of four or five manufacturer's representatives. This kept me on the road a good deal. With a price war on, and the company desperately in need of new business, I managed to land a large customer for our biggest plant. This made me something of a hero among my peers and the plant workers and gave me a surge of self-confidence.

Dede arrived soon after with our girls and a baby boy, Peter. We all settled down in that small picturesque community, a dramatic change from social life outside Baltimore. We began in Spruce Pine with no one but one another and our children, and even though I worked long hours our marriage bloomed. We started to make friends among the proud people of Spruce Pine. They were used to hard knocks, wanting nothing handed to them. Dede's cause célèbre was getting toilet seats installed in the school our daughters attended—a pretty big deal in that place and time. No liquor was sold within fifty miles of Spruce Pine, so most of the drinking took place in automobiles and much of that was bootleg corn liquor.

After about two years, though, I knew it was time to move closer to the center of

things. I could manage Feldspar and make my own sales trips as easily from New York as from North Carolina. I suggested to my mother that she "put a bug in Mr. Thiele's ear." Sure enough, about a month later I was called up to the parent company's headquarters in Manhattan. Dede went north ahead of me and found a lovely New Jersey country house on about ten acres between Lawrenceville and Princeton. We bought it for about $60,000 in 1960 and live there still.

For the first time since leaving college I now felt I had a future. Soon after my move to New York, Pacific Tin's president Norman Cleaveland and vice president Stuart Miller decided to send me to Kuala Lumpur, Malaysia, for a crash course in

Dad and his fifth wife, Paulette, in the late 1940s

tin mining. Dede and I left the children with my mother at her plantation in Yemassee, South Carolina, suggesting she let our lively young Irish nurse have some fun once in a while. Mom wondered. Sure enough, several months later we learned that the nurse was pregnant by a groom in Mom's stable. They later married and my mother was the child's godmother.

Living in Kuala Lumpur in 1969 was fascinating. I worked long hours but still had time to get to know U.S. Ambassador Homer Byington, play golf at the Selangor Golf Club, and stay up too late most evenings. Sir Henry S. Lee, the first finance minister after the British freed Malaysia, became a good friend. A Malaysian educated at Cambridge and knighted by the British, Lee was most imposing. Soon after I returned to the States he phoned me in my office to say he was in New York on a United Nations mission. Could he join us for the weekend? "Sure," I said. "Meet me at my office at 120 Broadway at 4:00 p.m., and we'll take the train to Princeton together."

Ambassador Lee arrived with golf clubs and a huge black suitcase with "Sir Henry S. Lee" emblazoned on it in big white block letters. Somehow I made it to the

station with his luggage and we had a splendid weekend. Next week I saw an old friend, George Young, who said he had accompanied an acquaintance who did not know me to the station the prior Friday. "Isn't that strange?" said this person to George. "Look at Sir Henry S. Lee carrying that heavy suitcase and golf clubs with his Chinese aide walking behind him!" Sir Henry would have loved that story.

That weekend we went to a black-tie dinner at a friend's. After an elegant meal, the men repaired to the den for cigars and coffee. After about ten minutes, Sir Henry stood bolt upright. "Peter," he announced, "we must be off." I retrieved Dede, who was enjoying herself immensely with the other wives, and the three of us drove home. I tactfully asked Sir Henry if everything was all right. He said yes, he was fine, but had presumed he outranked all the other guests, who could not leave before him, so for their sakes he had no choice but to depart.

Mom at Big Survey Plantation in 1967

Within a year after moving to New York from North Carolina I was made vice president of Pacific Tin. My salary was modest, but Grandfather Solomon had set up a trust that paid me about $12,000 a year. Though we weren't living high on the hog, Dede and I did send the kids to private schools and joined several local clubs. I played gin rummy during the commute on the Reading Railroad train to New York from nearby Hopewell. We comfortably assumed that we would be old before Grandpa's inheritance would come to me at my mother's death. More importantly—to me, at least—I had earned, rather than inherited, this modest degree of success.

And for the first time I began to understand, on a purely intuitive level, the power of the art my family had helped bring to public consciousness. My "conversion" happened in a single afternoon in the early 1960s. Dede and I were at the Tate

Gallery in London and had just come through several rooms of what seemed to be endless depictions of naval warfare. I'd been lulled into unadmitted boredom when we stepped into a room full of Mondrians, Picassos, Klees, and Kandinskys. I literally felt as if I were breathing fresher air. In a flash, I realized that art could be beautiful and breathtaking without the viewer's having to understand what the artist is "saying." The art that graced my grandfather's Plaza apartment, which until that moment I only dimly recalled as "wallpaper," came back to me in an entirely different context. For the first time I saw what my grandfather had seen in this brave new art.

When I returned home, I began to explore the Guggenheim Museum and its governing foundation—that part of my family's legacy that, though fueled by enterprises like Pacific Tin, had long ago eclipsed those enterprises in the public imagination.

III

COUSIN HARRY
The Heir Apparent

When I became Pacific Tin's vice president, I moved to the head office in the Equitable Building at 120 Broadway, where I found myself on the thirty-fifth floor along with the other principal Guggenheim entities. From his own sumptuous office overlooking the Hudson River, my cousin Harry Guggenheim—son of my grandfather Solomon's brother, Daniel—dominated this arena.

Grandpa Solomon was the last surviving of the seven Guggenheim brothers of his generation, and when he died his nephew Harry Frank Guggenheim became, at fifty-nine, the family patriarch. A Cambridge University graduate, Harry had by then achieved a great deal. A nationally known figure, he had served as a naval aviator in World War I and, in World War II, as commandant of the award-winning Trenton Naval Air Station. He had served as ambassador to Cuba under President Herbert Hoover. He'd written several books (one being the incisive *United States and Cuba* published by MacMillan in 1934), and he was senior partner in Guggenheim Brothers, which had incubated so many of the family mining enterprises.

Harry had also developed a world-famous thoroughbred horseracing stable, which in 1959 won more prize money than any other stable in the country. His assistant, George Fountaine, remembered Harry saying at the time, "There's only one way we can go now—that's down." I have been reliably told he did as much as any breeder to improve the bloodlines in that business. In 1953, four years after Grandpa's death, Harry's Dark Star won the Kentucky Derby over Alfred Vanderbilt's Native Dancer. In keeping with his perfectionism, Harry changed trainers frequently

Harry Guggenheim on the deck of the aircraft carrier U.S.S. Nehenta Bay in 1944

and took a keen interest in the smallest details of the breeding, care, feeding, and training of his horses. Many of his stallions' progeny show up in winners' circles today.

He owned a magnificent mansion, Falaise, in Sands Point, Long Island, just up the road from my grandfather's estate. He also owned a plantation, Cain Hoy, which encompassed Daniel Island, a spectacular property near Charleston, South Carolina (two tracts totaling 16,000 acres located between the conflux of the Cooper and Wando Rivers), where he raised cattle, grew timber, and hunted wild turkey with World War II generals James Doolittle, Nate Twining, Pete Quesada, Pat Partridge, Hank Everest, and Senator Harry Byrd. After Harry died, I continued to entertain these honored guests, as well as my own friends.

In partnership with his third wife, Alicia Patterson, Harry also founded *Newsday*, the daily newspaper for Long Island and New York City, which became an early success at least in part because of Alicia's newspaper expertise and background. Her father was the famous Captain Patterson, publisher of the *New York Daily News*, whose cousin was the equally famous *Chicago Tribune* publisher, Colonel McCormick. *Newsday* was for a while the nation's fifth largest newspaper.

Permit me a short digression. Though Alicia and Harry struck me as a devoted couple, they led quite separate lives until her death in 1961 from complications arising from an ulcer operation. Alicia had her own plantation in Georgia and wrote liberal *Newsday* editorials in total conflict with Harry's more conservative views. (In side-by-side *Newsday* announcements on the eve of a presidential election, they would each back their respective candidates). I remember once seeing Alicia at a Princeton football game with Adlai Stevenson when he was running for president. Though there were rumors, I know of no hard evidence that he and Alicia were more than warm friends. Nevertheless, Stevenson wrote Alicia some eloquent love letters when he was governor of Illinois in the late '40s. Read them and judge for yourself:

May 1948 [?]

Dear—It's midnight again and the last of the politicians and professors has just left. I'm about to topple into bed. Up and away for Danville (?) at 8—and so on and on to the end of time or until my sins are expiated—or until the morning comes when I just can't get up again.

 I wonder what the hell I'm doing and why—and then I think again and that you think it's good and worth while and wouldn't love me if I didn't behave this way—and then I get up and go at it again.

Feb. 28, 1949

Darling—it's Monday—10 a.m. I've just flown in from Chi[cago] and find your letter (unopened and chaste!) sitting on top of my pile. I fled to the plane to read it in peace and security. And now I have that silly, ridiculous, undignified, non-Gubernatorial feeling all over again—well you really do give a stiff old guy an emotional massage, don't you. My little bird woman.

Apr. 5, '49

Darling—I'm getting so damn tired of this job. I can't even decide whether to sign or veto the bill investigating communism at the U of Chicago & Roosevelt

College. If only you were here you would have all the answers—and besides I'd get to bed earlier!

Believing (as John Davis put it in *The Guggenheims*) that "inherited wealth should be used for the progress of man," Harry had spent most of his considerable wealth, and much of his time, on socially useful projects. Through one of his father's philanthropic vehicles, the Daniel Guggenheim Fund for the Promotion of Aeronautics, Harry had helped blaze the trail of aviation from its early days in the 1920s and '30s. He and his father were persuaded by Charles Lindbergh to back rocket experimentation in the early 1930s through the Daniel and Florence Guggenheim Foundation, which Harry also headed. And Harry supported Robert H. Goddard's research at a time when the U.S. government was showing little interest in that "father of rocketry."

When Grandpa died, Harry was the obvious successor to the patriarchy, having already done so much to carry on the Guggenheim tradition. Actually, Harry had no competition, since most of his uncles had fathered daughters who, in that prefeminist era, were not considered qualified for the position as they might be today, and had in any case revealed no interest in business. Harry's older brother, Robert, was more interested in Washington politics than New York business and art. So Harry assumed the mantle quietly, without fanfare, almost by divine right.

Considering how profoundly Harry would influence my life, it's surprising I knew so little of him or his accomplishments when I was growing up. But my mother was never close to Harry and seldom spoke of him—certainly never held him up to me as a role model. She preferred Harry's older brother, the charming and debonair Robert. My mother was particularly amused by an incident that occurred soon after Robert's posting as ambassador to Portugal by President Eisenhower: At a state dinner he playfully dropped an olive into the cleavage of the prime minister's wife, and then compounded the prank by trying to retrieve it with a spoon. Eisenhower

soon recalled him, ending Robert's diplomatic career. (I have boyhood memories of Robert, who visited us often, since he had a plantation called Poco Sabo only a few miles from Grandpa's Big Survey plantation in South Carolina. I remember the "memory pills" he freely popped in later years.)

Harry's fame in horseracing and horse breeding may have aroused my mother's envy, since she had her own, less successful stable. Mainly, I think my mother seldom mentioned Harry because he was simply too serious for her. After all, had she been a man, she surely would have been more like the carefree Robert than the dedicated Harry. I was told that Robert and Harry's mother, Florence, favored Robert over Harry, probably for many of my mother's reasons.

By the time I came to 120 Broadway, I was, of course, fully aware of Harry's eminence as family patriarch. Among other things, he was president of Grandpa's foundation, which operated the Solomon R. Guggenheim Museum. He was a perfectionist, impatient with mediocrity, a tough taskmaster toward everyone he worked with—including himself. Everyone on the thirty-fifth floor was in awe of Harry, and so was I, to the point where I shied away from meeting him and had only occasional glimpses of him getting on or off the elevator. He was easily recognizable, wearing a proper felt hat, standing very erect, and dressed impeccably in his tailored business suit.

It took many months for me to get up the courage to request an appointment to meet him. There was nothing I really wanted from him, my horizon being limited at that time to Pacific Tin, of which I felt I might well become president someday. The thought of a future in other Guggenheim entities had not seriously occurred to me. My Princeton friends were asking me questions about the Guggenheim Museum, however, and I thought it would be nice to be able to answer some of them. At this time my mother, my half-brother Michael, and my aunt Eleanor were all trustees of the Solomon R. Guggenheim Foundation, along with Harry and Alicia. Clearly there was no good reason to add me. Still, I decided, with trepidation, to approach Harry to become better informed about the museum.

So we met in 1961—not in Harry's spacious main office but in a small office next to the Guggenheim Brothers' "Partners' Room," the famously huge, wide-windowed chamber looking onto the lower Hudson River. He was bald, had rather strong features and piercing blue eyes, and was dressed impeccably and conservatively. His motions and general deportment were smooth, self-assured, and deliberate. He spoke in soft, measured tones and struck me as enormously dignified.

His assistant, George Fountaine, had reminded Harry that I was his cousin Barbara's son and worked for Pacific Tin. We began with small talk, mainly about my mother.

Harry Guggenheim, Henry Cabot Lodge, and Bernard Baruch at the opening of the Solomon R. Guggenheim Museum in New York on October 20, 1959

Maybe Harry didn't want to intimidate—or completely paralyze—me. I was intimidated enough as it was. I finally got up the nerve to explain my wish not to become a museum board member but simply to be kept informed unofficially, perhaps "put on the mailing list," as an interested relative. He was gracious but cool. I had a feeling he would check me out thoroughly.

Sure enough, about a week later George Fountaine phoned to tell me that "the Captain" (as Harry was often called following his World War I service) wished to see me again, this time in his main office. When I arrived, Harry said he was overruling my wish not to go on the foundation board and would like to appoint me the museum's vice president for business administration, responsible for all non-art functions. Albert Thiele, my first Guggenheim "patron," trustee of my grandfather's estate, and also a foundation vice president, was incensed

that Harry had made this appointment without his knowledge. George Fountaine tells me that "the Captain" phoned Albert as follows: "We old-timers have to look to the future; that's the place where the young, bright, energetic fellows come in. We need that, Albert, my boy!"

Several years prior to my meeting Harry, Albert Thiele had retired from his role as a director of Kennecott Copper Corporation and was kind enough to recommend me as his replacement. Frank Milliken, then president of the huge mining company that had once been controlled by the Guggenheims, accepted his recommendation. That evening, on the train back to Princeton, I confided in my friend, Ralph Peters, about my good fortune. Ralph was such a good listener that we both neglected to disembark at our destination in Hopewell and ended up in Jenkintown, Pennsylvania, necessitating a long taxi ride back to Princeton.

In addition to being a most interesting experience, serving on the prestigious Kennecott board granted me a quantum leap in stature in the business world. Getting to know fellow directors like W. R. Grace chairman Peter Grace, Morgan Bank president Walter Page, and Thayer Tutt, who owned the Broadmoor Hotel in Colorado Springs, began to make me feel I was on a roll.

Apparently Cousin Harry's investigation had satisfied him that in addition to some ambition and growing family pride I had some business ability, because he also made me a partner in Guggenheim Brothers, the family firm active in mining exploration under the leadership of his nephew, Oscar Straus II. Since it would be necessary for me as a partner (my participation was 5 percent) to pay my share of ongoing expenses—in addition to investing in projects as they developed—Harry talked my mother into staking me to $12,000 a year. Without this backing I could not have afforded to join the firm in 1962. This was a pivotal turning point in my life—and when Harry called me in to tell me about it, I was of course enormously grateful and complimented him on his success in obtaining my mother's financial support. Later, Harry himself began giving me a year-end gift, which I plowed into the partnership.

When I had come back to earth and begun functioning as a trustee and officer of the Solomon R. Guggenheim Foundation, I took some of the administrative load

off Harry's shoulders and soon found myself making recommendations to him about day-to-day museum operations.

Harry invited me often to Cain Hoy and gradually gave me responsibility for overseeing its operation as well. Having spent a considerable part of my life at my grandfather's plantation, Big Survey, in Yemassee, South Carolina, I was somewhat prepared to deal with South Carolinians and the managing of such properties. One of the first decisions Harry asked me to make was not a difficult one. The state of

South Carolina wished to pave a dirt road that cut through the perimeter of Cain Hoy and led to an African-American residential community. Knowing it would be a terrible disservice to our neighbors to try to prevent such an improvement, I told Harry we had no choice but to agree. Although Harry did not relish modernizing his plantation in any way, he readily agreed with my decision.

Harry (center) chatting with his friends Jimmy Doolittle and Charles Lindbergh at Falaise in 1959

In other ways as well, Harry accelerated my involvement in his affairs. In 1967, he brought me on the board of the Harry Frank Guggenheim Foundation, which he had formed years earlier at the suggestion of his friends Charles Lindbergh and General James Doolittle. These three men were concerned that although America could put a man on the moon, little progress was being made toward improving man's relation to man. The purpose of this new foundation was, and is, to support research into man's behavior, in the hope that the knowledge produced may some day reduce the likelihood of wars and improve human relationships. I did not anticipate, when we held our occasional sessions with people such as the noted author-anthropologist Robert Ardrey, that some years later I would be launching the foundation's program as chairman.

In all this, I felt greatly flattered and privileged. But I had no idea of the ultimate destiny he had in mind for me until one September day in 1968 when George Fountaine walked briskly into my office at Pacific Tin and said, "The Captain wants to see you in his hospital room at Sloan-Kettering." (The doctors had urged Harry to undergo a prostate cancer operation, but he had said no: he was not afraid of death. Several years earlier, sitting with him by the fire in the living room of his Cain Hoy plantation one evening after dinner, I had asked him if he had a fear of dying. He rocked back and forth in his rocking chair. "Peter, if I should die in my sleep tonight, I can think of nothing more beautiful.")

"He wants you to bring this with you," Fountaine said, handing me an envelope.

As I entered Harry's hospital room, Harry was sitting up in bed, looking pale and drawn and sad. "Hello, Peter," he said. "Is that the envelope I asked George Fountaine to give you?" He was always soft-spoken, but his voice was softer than usual.

"Yes, would you like me to open it?"

"Yes, please, and read what's in it. I think it may interest you." He smiled faintly.

I saw at once that it was his will. My heart started to pound as I read and began to realize that Harry had decided to make me his principal heir. My inheritance was to include his home at 34 East 74th Street, a parcel of land on his Falaise estate overlooking Long Island Sound, and the plantation in South Carolina, which was to be mine during my lifetime and ultimately revert to the Harry Frank Guggenheim Foundation.

And there was more. In addition to these remarkable material gifts, Harry had also bequeathed to me the mantle of responsibility for all of the Guggenheim enterprises and philanthropies directed by him.

"Harry, I'm in a state of shock!" I told him through tear-filled eyes. "Why me?"

"Peter," he said in his soft voice, "I have been watching your progress over the past several years and there is no one else to whom I could comfortably entrust this responsibility. Also, you have a fine family of your own. And you are a gentleman."

Why Harry had decided to make me his sole heir was not clear to me at that moment. A later reading of a memorandum to his executors made it clearer. He said that to be effective as head of the family, I must have "adequate financial resources,"

and that "while inherited wealth can sometimes lead to a parasitic life and be destructive to society and the legatee, it can also be the means of constructive work on behalf of humanity and the greatest ultimate happiness to the legatee. If I were to provide for all of my family equally, none of them, in my opinion would be in a position to carry on the family tradition effectively."

He said he wanted to arrange matters so that one member of the family

would have the opportunity and would assume the responsibility of carrying on the Guggenheim family tradition. . . . The Guggenheim family has helped to develop the natural resources of the world, has pioneered in the development of the air age and rocket age, and has, in many other respects, through both its business activities and its philanthropies in education and art, benefited mankind in general in many parts of the world and especially in the United States and the Western Hemisphere.

The initial requirements for one to carry on such a tradition are . . . character, integrity, a capacity for leadership, innate ability, preferably a superior education, and an urge to work and a determination to succeed. . . . On the basis of long and careful observation of his potentialities, I believe that Peter O. Lawson-Johnston, a grandson of my uncle, Solomon R. Guggenheim, is fully qualified to carry on creditably the Guggenheim family tradition. I have given my trustees discretion to make distributions of principal to Peter to enable him to use his human and financial resources for the progress of man in the best traditions of the Guggenheim family.

I learned later that Harry, knowing he would not live much longer, had been working intensively with his lawyers on that will. He had envisaged a sort of board of directors to continue *Newsday* and other projects after his death. I was to be co-executor, along with Bill Moyers, publisher of *Newsday*, and John Peeples, chairman of Anglo Lautaro Nitrate Company, the Guggenheim-controlled mining company in Chile. The subsequent sale of Harry's *Newsday* interest (of which more later) changed the situation, and he sought the advice of his old friend, John W. Hanes, who, I am told, quickly sized up the situation and said, "Harry, you're not going to saddle Peter with a committee after you're gone, are you?" So he didn't.

What had started out as a wish to meet Harry, and which, out of admiration and respect, had become a desire to serve him—unless he had a change of heart!—put me in charge of the Guggenheim's principal interests, with some of which I had had virtually no previous contact. And for this I was to be rewarded handsomely for life.

I left the hospital in a daze, returned to my office, and handed the envelope back to George Fountaine, who, though he must have known what was in it, had the good sense and good taste not to comment.

On the train to Princeton—I left for home early, not wanting to encounter my commuting buddies until I had recovered from the afternoon's shock—I tried to sort out my feelings. When Dede arrived home, I asked her to join me in the library. She knew something momentous had happened. Our conversation went something like this:

"I visited Harry at the hospital today."

"Has he had a setback?"

"No. He wanted me to bring him his will, and read it, which I did."

"And?"

"Guess who he's making his principal heir: Me."

She said, "Well! What a surprise!"

I agreed.

"Why are you looking so worried?"

"It's not just property he's leaving me, but an enormous responsibility." And I told her in detail what it would be, and what a challenge to handle it.

"You're already handling a lot of it," she reminded me.

"There'll be a lot more. And I won't have Harry there to back me up when I've taken over. It's worth it, but this is going to change our lives quite a lot."

We talked through dinner and far into the night. Our conclusion: Harry would soon be out of the hospital and would probably live for several more years, with me under observation. If he saw I was not equal to the burden he was planning to put on me, he could—and, being Harry, *would*—withdraw it. On that disconcerting note, I tried to fall asleep. Next day I functioned normally, but life would never be the same for me or for my family again.

I felt apprehensive partly because Harry had never been the kind of "boss" who would call me into his office at the end of the day, put his feet on his desk, and explain his philosophy, his own approach to being a philanthropist. I hoped he might start coaching me a bit more after deciding to make me his heir, but he remained his somewhat distant, aloof self to the end.

My mother was pleased, of course, partly because Harry's decision permitted her to will her estate to my brother Michael instead of dividing it between us. On the other hand, I think she was a little annoyed because my new independence diminished her control over me. In more ways than one, Mom liked to be in the saddle.

Only once, to my knowledge, did Harry question his decision to make me his heir. He had asked John Hanes to look into his will—and John had suggested some revisions to the lawyers. One morning Harry called me from Florida and accused me of giving the lawyers instructions advantageous to me. I was angry and hurt, but respectfully suggested he check with John. Hanes told him, "Harry, you're hallucinating." Harry called me back, told me what John had said, apologized for being hasty. I forgave him, of course, knowing he was on painkilling drugs and was naturally inclined to mistrust people, having been taken advantage of a few times. Ironically, the incident reinforced his faith in me, and there was never another.

I lived with the knowledge that Harry had a history of being hot and cold on people and in his present state might disinherit me in a new will. But I didn't dwell on it, figuring it wasn't the most important thing in life. I was doing well before his decision and wouldn't starve if he changed it. And I knew Dede could readjust, if necessary, as well as I could. But there was no more discord between Harry and me. Our relationship grew warmer and closer.

Harry seemed satisfied he had provided for his three daughters adequately through prior arrangements, but I was worried about what they thought of their father's having reached out to make a second cousin his heir. It would be only human for them to resent this, even though a heavy responsibility went with the financial reward. As it was, I received only support and friendship from his immediate family. I am told his sister, Gladys Straus, whom I did not know until after his death, was deeply upset with him, but she never displayed any personal hostility toward me

before she died in 1980. I have enjoyed friendly relations with her sons, Oscar and Roger (the latter, who died in 2004, was the "Straus" of the renowned publishing house Farrar, Straus, and Giroux). I knew I had the respect and affection of Harry's daughter, Joan Van de Maele, who was very supportive until her death in 2001.

One day in 1969, a year after the will episode, Harry told me he wanted to step down as president of the Solomon R. Guggenheim Foundation—that he was almost eighty and no longer relished the responsibility. He had decided to recommend me to the board as his successor. But he felt a bit uncomfortable in leapfrogging me, at forty-two, over the elderly vice president of the foundation, Albert Thiele. When Albert learned of the plan, he resigned as vice president—and this troubled Harry and me, since he was a grand old gentleman who had been totally loyal to the family and instrumental in arranging for me to succeed him as a director of Kennecott Corporation.

Harry threw this public relations problem into my lap, and I recommended he appoint Albert as chairman of the executive and finance committee—the only aspect of museum operations that interested him anyway, since he abhorred modern art. This solved the problem, and my relationship with Albert was not impaired. Having overcome this hurdle, I was elected president in December 1969 by the foundation's board of trustees.

Another incident indicative of my increasing involvement in Harry's affairs began one Sunday morning in February 1970. Dede and I were lying in bed when the phone rang at 7:30. It was Harry, in Florida.

"Peter, I need your help with a problem at *Newsday!*"

"Do you want me to fly down to see you?"

"That's the general idea."

Next day, at his beachfront motel cabin in Golden Beach, he produced a fistful of editorials that had appeared in *Newsday* in the past few months. They were unrepresentative of his views to the point where he was "ashamed to have my name on the masthead of my own newspaper!" So he was going to sell it.

He said that before Nixon's election victory over Humphrey, he, Harry, as major owner, had made a deal with his new publisher, Bill Moyers, former press secretary to

Lyndon Johnson, that the paper would support the president when he was right and give him hell when he was wrong. Now, only months later, Bill was proving to be a liberal Democrat who so hated Nixon that he could give him and his policies nothing but hell on the editorial page. (Harry, who had also differed philosophically from his politically liberal wife, was himself a "middle-of-the-road" Republican.) "Moyers and I watched the TV election returns together when Nixon was elected," said Harry. "We agreed and shook hands on that editorial policy."

"But," I said, "why sell *Newsday* just because you and Moyers differ editorially? Why not work out a generous severance arrangement and find another publisher?"

Well, said Harry, he was getting old, no longer had the stamina to continue running the paper, and wanted to put it into the hands of someone who shared his political views. "I've made up my mind to sell it to my friend Norman Chandler," owner of the Times Mirror Company, publisher of the *Los Angeles Times*.

I was deputed to contact the Times Mirror people and, working with John Hanes, to negotiate a sale without Bill Moyers's knowledge, which meant secretly obtaining financial data and other pertinent information about *Newsday*. Harry was afraid if Moyers knew what was up, he would fight either to retain his job or to make sure the paper was sold to a more liberal buyer. Moreover, Harry—who owned only 51 percent of *Newsday*—knew that his deceased wife's heirs, the Albrights, would be upset about the paper's being sold, particularly to a nonliberal owner. Better, he thought, to do it quietly.

Within twenty-four hours, John Hanes arrived in Florida and, based on price/earnings ratios and so on, we placed a price on Harry's controlling 51 percent interest in *Newsday*. John passed this on to the top management of Times Mirror, and soon we were meeting with Al Casey (subsequently chairman of American Airlines and then U.S. postmaster general); Otis Chandler (son of Harry's friend Norman); and Bob Erburu (chairman of the Times Mirror board). They were easy to deal with, and within hours we had a verbal agreement to sell *Newsday* for $75 million.

Sure enough, when the deal was announced we were flooded with offers from liberal publishers—and no doubt we could have gotten a higher price. But that had not been Harry's concern. He wanted *Newsday* in what he considered the right hands.

In the years since, Times Mirror has done a good job of developing *Newsday* into a first-class paper. On the other hand, its editorial policy has been nowhere near as middle-of-the-road conservative as Harry might have hoped. Ironically, although Norman Chandler shared Harry's political philosophy, his son Otis was perhaps just as liberal in his views as Bill Moyers—and since Otis was in control of Times Mirror's editorial policy, Harry had sold his paper to the wrong company, ideologically speaking, after all.

Having been on friendly terms with Bill Moyers for several years, I was uncomfortable about my role in this affair, but Bill was understanding, and I did get him an excellent severance package. He was, and is, a man of deep convictions, good humor, and great personal warmth. I've always regretted that we fell out after Harry died— over the wording of a press release regarding Harry's will that Ivy Lee, a public relations firm long employed by Harry, strongly insisted on sending out, which mentioned that Bill had been taken out of the will. I thought it was rubbing salt in the wound, but those "experts" ignored my advice.

The entire *Newsday* episode gave me the opportunity it gave me to meet and become a close friend of the late John Hanes, a man thirty years older than I, successful, brilliant, and charming. We visited Harry together in the months and weeks before Harry's death at his home, Falaise, on Long Island. Their friendship was very close. I remember Harry asking John whether a gift of $100,000 to John's private foundation would be suitable in recognition of his role in the *Newsday* sale. "Harry, double it and it will be just right," he said. That was fine with Harry. Had they not been such close friends, the fees on a deal the size of the *Newsday* sale could have been close to $5 million.

Despite his distant manner, I learned a lot from Harry and was impressed with his forcefulness and no-nonsense approach to problems. He expected people to measure up, and if they didn't he crossed them off his list. This could seem cold-blooded, particularly when applied to family members, but he obviously felt life was too short to accept less than optimum performances and results.

He was, indubitably, a leader. Even at Cain Hoy plantation he planned each day's activities in detail. He sometimes reprimanded distinguished guests for failing to

follow his strictures in the hunting field. I think Captain Harry's being such a tough taskmaster is one of the many reasons he was so widely respected.

Typical of Harry's perfectionism was his insistence on the very best advice in his plantation activities, in raising quail, in managing his cattle, and in cultivating and thinning his timber. He was similarly tough and perfectionist in running the business affairs of the Guggenheim Museum, as evidenced by the following memorandum he wrote to its business manager Glenn Easton on February 1, 1965, just after the trustees' decision to build an annex behind the small rotunda on 89th Street:

> Your letter of January 27, 1965, "Second Draft of Proposed 1965 and 1966 Museum Budgets," is not acceptable. Your recommendation once more to raise the admission fee is not part of your duty of preparing a budget.
>
> Our museum expenses are too high and must be curbed. The budget is not to be balanced by adding to the burden of the public but in reducing, not increasing, the cost of administration. . . . The posture of constantly increasing expenditures and placing the responsibility of finding the money on the President and Trustees is an incorrect one.
>
> This attitude accounts for the exorbitant construction proposals that were permitted to be planned by the architects until I was forced personally to investigate and control the proposals. . . .
>
> Your memo is not approved. There are many expense items which I shall point out to you that are not realistic and should be eliminated.
>
> Harry F. Guggenheim

Many of Harry's decisions were not as fully appreciated. Mother was not above criticizing him. This letter, found in Mother's desk after her death, was written in response to her complaint at not being included as a Guggenheim trustee at a White House affair:

May 15, 1959

Dear Barbara:

This is a very difficult letter to write.

After the meeting yesterday a message came that you were disturbed, in fact "irate" because you had not been invited to the President's presentation to Joan Miró of The Solomon R. Guggenheim International Painting Award. I am sure that you can't be familiar with the circumstances of this presentation.

The award that the President will make is not in any way in honor of The Solomon R. Guggenheim Foundation. It is an award, like the Carnegie Medal, the Pulitzer Awards and the Nobel Prizes, and in all of these cases the honor is not to the donors of the award or their families, but to the recipients. It would be unseemly if the members of the Guggenheim family should exploit the President's consent to make this presentation. The only reason that I shall be present is because, first, I am the chief executive officer of the Foundation, and second, because at my personal suggestion to the President at a private dinner at the White House he consented to make the presentation. The idea of an International Award was mine, and I discussed the plan with the President.

I have had some embarrassment in taking the place of Uncle Sol's children in administering the Foundation. Arthur was named President and at your father's suggestion I went on the Board as a family duty about six months, as I recall, before his death, not with any idea that I was going to administer his Foundation. However, Arthur was able to spend very little time in the United States, and while he was still President and I was Chairman of the Board, in order to administer in his absence, he requested me to assume the Presidency. I told him that I would not do so because I felt that some one of Uncle Sol's immediate family, not his nephew, should have that place. Arthur finally decided to resign, and the job fell to me.

Most of these foundations are usually administered by a paid executive, and I have no doubt that you could find someone with far more knowledge in the art world to do a far better job than I can do. However, it fell to my lot to take over the unfortunate situation created by Hilla Rebay, also to get the Frank Lloyd Wright building completed, in spite of the architect's determination to spend five million dollars and to go counter to all the building authorities in the city, including Park Commissioner [Robert] Moses.

The presentation on Monday is an honor for all concerned, but I can assure you it is more of a burden to me than the honor that I will feel in being there. As

I told you at the start of this letter, [it] is hard to write, but I think you should have this very full report.

> Affectionately,
> Harry

Before Harry died, he took some steps to facilitate my job as his executor. He disposed of his racing and breeding stock at a record sale held at Belmont Park. (His stallions were sold privately, including Derby winner Dark Star). And later he auctioned all his cattle in South Carolina.

SILVER COLLECTION in Capt. Harry F. Guggenheim's Long Island mansion will be enhanced by the trophies won by Cain Hoy Stable's Ack-Ack in the Withers at Aqueduct. The presentation is made to Newsday's publisher (at left) by Thomas Trotter, racing secretary of the New York Racing Association.

Harry accepting a trophy won by
Ack-Ack in 1969

Only three days before his death I got a call from Charlie Wittingham in California, the trainer in charge of Ack-Ack, Harry's only unsold racehorse. Buddy Fogelson (husband of the actress Greer Garson) had offered $300,000. Would I, with my power-of-attorney, authorize this sale?

Far from knowledgeable about horse sales, I consulted two people whose opinions Harry valued highly: Humphrey Finney, president of Fasig Tipton Thoroughbred Horse Auctions, and John Hanes, who was former head of the New York Jockey Club. Both recommended that I "take the money and run"—and I did.

That year Ack-Ack won over $400,000 on the track and was named the prestigious "thoroughbred horse of the year." He was put out to stud in 1972. He commanded very high stud fees subsequently and was one of the nation's leading sires. Thank heavens some of my subsequent decisions have turned out better!

The frequent visits John Hanes and I made to Harry prior to his death at Falaise I found depressing because of Harry's condition—flat on his back and, near the end, unable to talk because of a stroke. John and I would discuss for about a half hour every conceivable topic that might interest him, kiss him on the forehead, and depart.

He had been such a proud gentleman, so dignified in his demeanor, so articulate in conveying his thoughts, and so admired and respected by his peers, it was heart-breaking to see him brought so low.

I don't think my father and Harry ever knew one another, but I think they would have gotten on well because they were both gentlemen. Harry was a Cambridge gradu-ate, and Dad never got beyond Eton, but they both possessed a certain gentlemanly manner that is, or used to be, instilled in those attending such institutions.

Harry had many friends, from American presidents to his favorite jockey, Manuel Ycaza. Alas, his sometimes grim perfectionism made him more respected than loved. In his later years, I can remember sitting with him by the hour, time marked princi-pally by long silences. He was not interested in small talk—but he did have a sense of humor. I remember his saying: "There are three phases in life—young, middle-aged, and 'My, you look well.'"

George Fountaine told me that one of Harry's favorite cracks was: "They're going to have to give me three weeks notice if they expect me to make a speech extempora-neously." George also remembered that when he and his lovely wife, Genevieve, had their fourth son, Harry called and left a message: "Please tell George to keep trying so he can make a basketball team." During his illness, when frequent samples of his urine and blood were delivered to his physician, Dr. Bill Rawls, Harry would take great delight in calling his doctor daily, saying, "Good morning, Bill, how am I?"

When he broke his back at Cain Hoy in 1959, Harry dictated letters to George Fountaine in response to notes of sympathy from friends, which he ended with the phrase, "A dog doesn't know he's a dog until he has fleas"—which rather puzzled George and me but which Harry obviously thought amusing.

Once when I visited Harry at Falaise by myself, I told him in some detail what was going on at Cain Hoy. He murmured, "A good report." I believe these may have been his last comprehensible words. I treasure them.

He had planned so long for death and was so methodical in arranging for it that the impact of my succession was not devastating. I had held his power-of-attorney for two years and so, in a sense, had already been carrying on.

Harry was such a proud man that I knew he was eager to die with dignity, and I knew from my memorable chat with him at Cain Hoy that he was ready. It was something of an anticlimax when he actually passed away peacefully, on January 20, 1971, at the age of eighty. Although sad, I was, in a way, happy for him.

In the letter accompanying his will, Harry Guggenheim wrote, "One of my primary objectives has been to arrange matters in such a way that one of the members of the Guggenheim family would have the opportunity and would assume the responsibility of carrying on the Guggenheim family tradition in the constructive use of the funds available to them."

It has been my extraordinary good fortune to be the one he chose.

In a few short-seeming years and one stunning afternoon, I went from a schoolboy with no awareness of his Guggenheim roots to patriarch of a major branch of the family, determined to guard its good works and move them into the future. My Guggenheim genes must be strong: Though I have had to work much harder than my dear father would approve of, I have enjoyed it and felt comfortable in my patriarchal role, as I guess Harry anticipated I would.

Harry's legacy to me includes a wide array of treasures and challenges, among them the Harry Frank Guggenheim Foundation, which supports groundbreaking scholarly research in human relations; Guggenheim Brothers, the family partnership formed in 1916 to succeed M. Guggenheim's Sons and which supports mining enterprises; and various other businesses described and brought up to date in the appendix. (Other members of the extended family control the John Simon Guggenheim Memorial Foundation, which bestows the Guggenheim Fellowships to creative artists and scholars, and the Daniel and Florence Guggenheim Foundation, endowed by Harry's father to encourage the development of aviation and rocketry.)

My principal responsibilities, however, lie with the Solomon R. Guggenheim Foundation, whose global purpose is to operate and administer the Solomon R. Guggenheim Museum in New York and in sites around the world, as well as the Peggy Guggenheim Collection in Venice, Italy. In all these endeavors, I am, and have always been, in effect, an "inside outsider." From my earliest days as assistant to Harry Frank Guggenheim when he was president of the board of the Guggenheim Foundation through my own years in that position, I have been ideally positioned to observe historic developments at the museum—without being sufficiently responsible for those developments to write about them with too much vanity.

I have had the particular pleasure of being associated with two very different museum directors at the Guggenheim. Tom Messer, Czechoslovakian by birth, is debonair, articulate, diplomatic, and during his Guggenheim tenure was more interested in curating than administration or fundraising. Tom Krens, on the other hand, is a visionary with incredible chutzpa, indefatigable and totally dedicated to raising funds in order to finance his highly ambitious dreams for the museum.

The tenures of these two extraordinary men encompass extraordinary expansions of the Guggenheim collection, additions and improvements to Frank Lloyd Wright's masterpiece on New York's upper Fifth Avenue, "taking the museum public" after it had been supported entirely by an endowment set up by my grandfather, and the worldwide expansion of the *concept* of the Guggenheim, from the incorporation of the Peggy Guggenheim Collection in Venice to sites in New York, Bilbao, Berlin, and Las Vegas. The story of my life as a Guggenheim necessarily includes the stories of these two men.

IV

TOM MESSER
The Guggenheim Comes into Its Own

The Guggenheim's third director arrived at the museum by a most circuitous route. Tom Messer was born in 1920 in Bratislava, Slovakia, which was then part of Czechoslovakia, and grew up in Prague. In 1939, at age nineteen, he was awarded a scholarship by the Institute of International Education to study in the U.S. He arrived in England just a day or two before Germany invaded Poland, whereupon he boarded a Cunard White Star steamer, the S.S. *Athenia*, which was crossing the Irish Sea on September 3rd when Britain and France declared war on Germany. Eight hours later a German submarine torpedoed Tom's ship. After a dramatic rescue, Tom, whose papers had been lost in the shipwreck, finally landed at Ellis Island, where, upon clearance by the emigration authorities, he proceeded to Thiel College in Greenville, Pennsylvania, the school designated for his studies in America.

After two years of study at Thiel, Tom moved to Boston, where his godfather was a viola player in the Boston Symphony Orchestra, and enrolled at Boston University. He graduated in 1941 and went to work for the Office of War Information in New York as a multilingual monitor. He eventually enlisted in the U.S. Army (becoming an American citizen in the process) and was dispatched overseas as part of a military intelligence team. Tom reunited with his family in Prague when the war ended and spent a couple of years as a control officer with Radio Munich, the German broadcasting station of the American military government. After a short course of study in Paris at the Sorbonne, Tom returned to the U.S. in 1947, where he married Remedios

Garcia Villa, Remi for short, who had been a colleague of his at the Office of War Information.

Tom's first professional involvement with the arts was as director of New Mexico's Roswell Museum, which had been founded only a dozen years earlier with support from the Works Progress Administration. He worked there for three years, but took time off to enroll in Harvard's famous museum course and earn a master's in art history. He returned to Roswell in 1951 and a year later was called to New York by the American Federation of Arts, an organization that among its other activities provides the country's museums with traveling art exhibitions. Tom soon became the federation's director, and four years later he was named director of Boston's Institute of Contemporary Art.

In January 1961, Tom received a letter from Harry Guggenheim's secretary saying that Harry was seeking a new museum director. James Johnson Sweeney, Hilla Rebay's successor as director of the Guggenheim Museum, had just stepped down. Having won a few concessions from Frank Lloyd Wright over some aspects of the new museum building, Sweeney lost a row with Harry over whether the Guggenheim served a principally educational function (Sweeney's desire) or rather was supposed to attract as large an audience as possible (Harry's). Harry prevailed, of course, and Sweeney was out, though as the Guggenheim continued to evolve these two goals proved to be mutually advantageous. Guggenheim trustee Daniel Catton Rich, who had known Tom since his days at the American Federation of Arts, had suggested him to Harry as a potential successor to Sweeney.

Tom met Harry at the Guggenheim, where the two had a conversation that lasted no longer than twenty minutes. "Essentially, Harry wanted to know whether I could explain to people what modern art was all about," recalls Tom. "We parted; I went to the Harvard Club and found there a message from Harry saying, 'Please come to dinner tonight.'" Tom went, of course, and dined with a small group that included Harry's wife, Alicia. When the other guests departed, Harry took Tom back to his office and asked him if he'd like to be the director of the Guggenheim. "Yes, sir!" Tom promptly replied, accepting the position on the spot, no questions asked.

In taking the job, Tom also took a calculated risk. "I was forty-one," recalls Tom,

Solomon R. Guggenheim Museum, New York

Peggy Guggenheim Collection, Venice

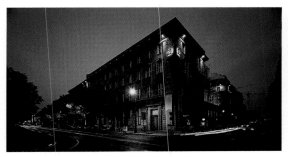

Deutsche Guggenheim Berlin

Sculpture Garden, Peggy Guggenheim Collection

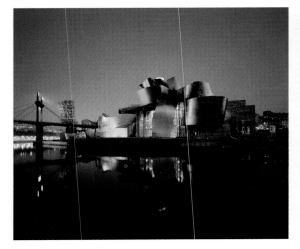

Guggenheim Museum Bilbao

Guggenheim Hermitage Museum, Las Vegas

Vincent van Gogh. *Mountains at Saint-Remy (Montagnes à Saint-Rémy),* July 1889. Oil on canvas.
Solomon R. Guggenheim Museum, New York. Thannhauser Collection, Gift, Justin K. Thannhauser, 1978.

Paul Gauguin. *In the Vanilla Grove, Man and Horse (Dans la Vanillère, homme et cheval),* 1891. Oil on burlap.
Solomon R. Guggenheim Museum, New York. Thannhauser Collection, Gift, Justin K. Thannhauser, 1978.

Pablo Picasso. *Woman Ironing (La Repasseuse),* 1904. Oil on canvas.
The Solomon R. Guggenheim Museum, New York.
Thannhauser Collection, Gift, Justin K. Thannhauser, 1978.

Pablo Picasso. *Accordionist (L'Accordéoniste),* Céret, Summer 1911. Oil on canvas.
Solomon R. Guggenheim Museum, New York. Gift, Solomon R. Guggenheim, 1937.

Robert Delaunay. *Eiffel Tower (Tour Eiffel),* 1911. Oil on canvas.
Solomon R. Guggenheim Museum, New York. Gift, Solomon R. Guggenheim, 1937.

Marcel Duchamp. *Nude (Study), Sad Young Man on a Train (Nu [esquisse], Jeune homme triste dans un train)*, 1911–12. Oil on cardboard, mounted on Masonite.
The Solomon R. Guggenheim Foundation, New York. Peggy Guggenheim Collection, Venice, 1976.

Constantin Brancusi. *The Muse (La Muse),* 1912. Marble.
Solomon R. Guggenheim Museum, New York.

Amedeo Modigliani. *Nude (Nu),* 1917. Oil on canvas.
Solomon R. Guggenheim Museum, New York. Gift, Solomon R. Guggenheim, 1941.

Vasily Kandinsky. *Composition 8,* July 1923. Oil on canvas.
Solomon R. Guggenheim Museum, New York. Gift, Solomon R. Guggenheim, 1937.

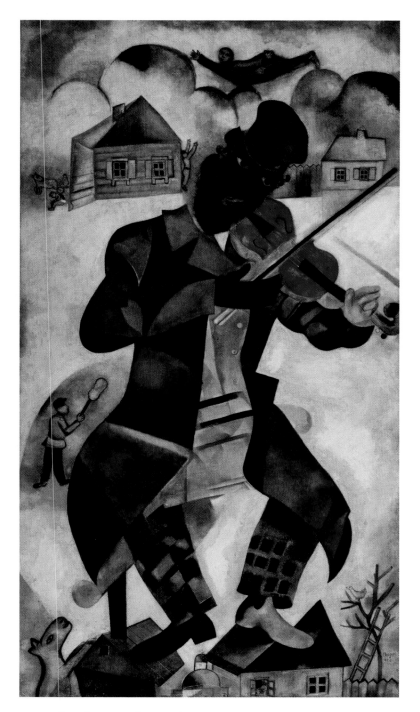

Marc Chagall. *Green Violinist (Violoniste),* 1923–24. Oil on canvas.
Solomon R. Guggenheim Museum, New York. Gift, Solomon R. Guggenheim, 1937.

Jackson Pollock. *Alchemy,* 1947. Oil, aluminum (and enamel?) paint, and string on canvas.
The Solomon R. Guggenheim Foundation, New York. Peggy Guggenheim Collection, Venice, 1976.

Jean Dubuffet. *Triumph and Glory (Triomphe et gloire),* December 1950. Oil on canvas.
Solomon R. Guggenheim Museum, New York.

Antoni Tàpies. *Great Painting (Gran pintura)*, 1958. Mixed media on canvas.
Solomon R. Guggenheim Museum, New York.

Richard Serra. *Strike: To Roberta and Rudy,* 1969–71. Hot-rolled steel.
Solomon R. Guggenheim Museum, New York. Panza Collection, 1991.

Dan Flavin. *the nominal three (to William of Ockham)*, 1963. Fluorescent light fixtures with daylight lamps. Edition 2 of 3. The Solomon R. Guggenheim Museum, New York. Panza Collection, 1991.

"and Harry was seventy-one. It was clear to me that my directorship would be dominated by Harry Guggenheim, who had his own ideas of how things should be run."

One of Tom's first challenges was to pay his respects to Hilla Rebay at Franton Court, the Connecticut estate she had been given by Grandfather Solomon. "She had nothing good to say about anybody," is what Tom now recalls from that encounter. "She certainly had no sympathy either for Sweeney or for Harry Guggenheim and did not hesitate to express her lack of it in forceful terms. But since I had come to pay homage to the de facto founder of the museum I now had the honor of directing, I felt I was in no position to argue, and therefore changed the subject."

Tom came to the Guggenheim steeped in the world of European postwar art, which ran against the domestic current in the 1950s and 1960s, both extremely chauvinistic decades for American art. Although modern art had originated in Europe, American artists, particularly the abstract expressionists, came on strong after World War II, and the market invested heavily in their work. In consequence, many American museums distanced themselves from the art of the same generation created outside America. With the Whitney devoted entirely to American art, and MoMA leaning strongly in the same direction, Tom thought at least one leading New York museum should lean the other way.

Tom thus made the Guggenheim the leading "outsider" institution, welcoming European and Latin American art in particular. For a long time his reputation among French and German art critics was higher than it was among their American counterparts. Since Hilla Rebay had been Eurocentric in her tastes and Sweeney (a native of Ireland) had been carefully impartial, Tom was actually following a Guggenheim tradition—though it was harder for him to do so than it had been for his predecessors. Still, Tom's vision was borne out in the end. Many of the artists he exhibited to negative reviews are now highly regarded throughout the world. In this connection one might recall one-man shows given at the Guggenheim to the Spaniard Antoni Tàpies, the Italians Lucio Fontana and Alberto Burri, and the Danish Asger Jørn, among many others. Although Jean Dubuffet had been shown in New York before Tom's time, his consistent sponsorship of this great Frenchman through the decades followed the same pattern.

Harry Guggenheim did not pretend to know much about contemporary art so Tom tried to help him appreciate it. Twice a month the two would visit the galleries together while Tom explained things to Harry. "In the end," recalls Tom, "Harry wanted to have someone constantly reassure him that this contemporary art was a bona fide enterprise." This was sometimes a difficult task, as Harry wasn't above referring to certain well-known artists as "hippies" and certain legitimate exhibits as "freak shows."

But Tom respected Harry, and the two men developed an intensely personal relationship. Harry was basically supportive of his new, young director, and he adored Tom's wife, Remi. The Messers often visited the Guggenheim estate at Falaise on Long Island, but Tom's challenge in sustaining that relationship—while at the same time sustaining his own vision for the Guggenheim—was constant. The largest issue, as is so often the case with the Guggenheim, was the conflict between the "art" of Tom's curatorial vision and the "business" of museum finances necessarily emphasized by his trustees. In addition to being an authoritative president, Harry had a history of dividing his subordinates' authority. Having contended with two difficult directors (Rebay and Sweeney), Harry now sought to retain undivided managerial and financial control. For almost a decade, Tom functioned essentially as chief curator with authority in art-related areas such as exhibitions and the collection. For everything else—art administration, business and public affairs—Harry appointed individuals directly responsible to himself.

The arrangement worked quite well for a decade, but over time Harry had more trouble with his business managers than he did with Tom Messer. One after another they were eliminated, with Harry's consent. All of them, that is, except for chief financial officer Glenn Easton, a former military officer and hard-nosed disciplinarian to whom Harry had granted veto power over all museum expenditures. Easton and Messer clashed more frequently with each passing year. By the time I joined the board in 1964, the growing tension between the two had resulted in a full-blown schism, though things were leaning slowly in Tom's favor. Harry's own relationship with Easton was strained, and he might have let Easton go earlier if—as Tom surmises—he hadn't been captured by that American prejudice that "art" people

aren't supposed to be as efficient as "business" people.

I suppose I may have been accused of the same prejudice, for I defended Easton, whom I admired, in my earliest years as trustee. When Harry appointed me president of the board in 1969, Tom came to me and said the situation had become intolerable and that I had to choose between him and Easton. I sided with Tom, but in doing so I made it very clear that he would have to be responsible for the museum's bottom line. Although I sensed such responsibility wasn't natural to him, Tom had conservative instincts and, much to his credit, wanted to run a tight fiscal ship. During our years together the Guggenheim ran in the black most of the time.

Tom Messer with The Muse

Through that initially difficult transition, Tom and I emerged as a team, and together we were able to meet the challenges that came our way—and there were some exceptional ones. One involved *The Muse*, a beautiful sculpture by Constantin Brancusi bequeathed to the Guggenheim by the watch millionaire Ardé Bulova. Tom loved that sculpture like his own child, caressing it with his hand while he proclaimed its brilliance to the museum's Arts Advisory Committee. Mr. Bulova was divorced at the time of his death and his ex-wife took us to court to contest our ownership of *The Muse*, laying claim to the precious object by contending that Bulova "didn't know a damned thing about art" and had only acquired the piece through her initiative (and friendship) with Brancusi. Our lawyers defended us ably until the New York Court of Appeals reversed the lower court's decision. One day

shortly after the verdict, our staff at the reception desk called up to report that armed U.S. marshals had arrived to retrieve *The Muse*, by force if necessary. Tom was understandably devastated.

Years later, toward the end of 1985, Tom received a call from David Nash, then a leading auctioneer at Sotheby's, saying, "I have something in my office you'd like to see." When Tom entered Nash's office, there on the desk was *The Muse*. The former Mrs. Bulova had sold it to a dealer who then got into legal trouble. The sculpture was meant to be part of an enforced sale at auction. Tom asked Nash not to put it on the block. "I'm sure we can come to terms," Nash replied. With the approval of the Guggenheim's Art Advisory Committee, Tom reacquired *The Muse* . . . for $1.2 million.

Not all of our joint endeavors had happy endings. One that did not resulted from Tom's scheduling of an exhibition by the German artist Hans Haacke, who recommended himself to one of Tom's curators on the basis of his innovative and provocative work. Tom, who believed in curatorial initiative, approved the show on the basis of an exhibition he had seen in a New York gallery but became apprehensive when he realized that the artist's subject matter was the presentation of slumlord abuse. Moreover, the culprits were to be identified by name. For Haacke, art was nothing more than a social weapon; he made no distinction between politics and art. After much soul-searching Tom decided to cancel the show and thereby inspired massive protests against the museum and his leadership. When a *New York Times* reporter called me to inquire about the position of the Guggenheim trustees, I told her that we supported Tom a thousand percent, thereby agreeing with his argument that the Guggenheim Museum was not a court of justice and in no position to determine individual wrongdoings. In this sense, politics was not part of our mission.

The argument was subsequently intensified by the Haacke-inspired assertion that the Guggenheims themselves were the slumlords and that Tom was in fact defending his trustees. We rejected the accusation, indicating readiness to go to court, and achieved denials and withdrawals of the charges from the *Times* and others. But the Haacke issue, with its implications of censorship, was a painful experience for us all.

There were other sleepless nights for Tom Messer and me, including one in 1969 when he phoned at 2:00 a.m. to say that a moving van, en route from a Guggenheim exhibit to a museum in California and carrying a priceless collection of Peruvian ceramic artifacts dating from 1500 B.C., had collided with a car in Texas, killing the van's driver. The works were irreplaceable, and Tom was greatly concerned. Should we awaken the Peruvian ambassador to tell him the grim news? I suggested we hold off—and try to keep the story from the press as well—until we knew the extent of the damage. Several nerve-wracking hours later we learned that the damage to the Peruvian art was minimal, a point that did nothing to reverse the tragic fate of the van's driver, of course. The incident never became public, and all the artifacts were ultimately returned intact to their owners in Peru—not an easy task, as a revolution had occurred there in the interim.

One of our greatest opportunities was one Tom brought with him when he came to the Guggenheim. Nine years before his appointment, in the summer of 1952, when he became director of the American Federation of Arts, Tom and his wife Remi had taken an apartment at 9 East 67th St. The weather was warm, the air-conditioning nonexistent, and Tom kept the windows open while he practiced piano every evening. A neighborhood friend told him one day that Justin K. Thannhauser, a renowned art dealer and collector who happened to live across 67th Street from the Messers, had been wondering aloud "who the hell's playing Beethoven sonatas over there?" The Messers soon met the Thannhausers, and in subsequent visits Tom became well acquainted with Thannhauser's magnificent collection of impressionist and postimpressionist works—his Van Goghs, Gauguins, and Picassos.

Arriving at the Guggenheim nearly a decade later, Tom realized that Thannhauser's exquisite possessions would magnify enormously the twentieth-century collection to which the museum was principally dedicated. Two years into his Guggenheim directorship, Tom had convinced Justin Thannhauser to give seventy-four works to the museum on permanent loan.

At the same time, he convinced the trustees that new space was needed to house all these treasures. We decided, as a first step, to free and refurbish the spaces behind the smaller rotunda, or "monitor" building, as Frank Lloyd Wright had called it. In

1963, we chose Wright's son-in-law, William Wesley Peters, to undertake this task. Mr. Peters was a cantankerous man to work with, and the entire undertaking was a nightmare for those of us involved in the project. When we were near to opening the newly reconstituted spaces in 1966, Thannhauser declared that his art must be hung in heavy, gilded frames on red brocade-covered walls. Harry himself delivered this news to Tom at home, where he was sick in bed. Harry asked if we should accept the collection under such terms. "Of course," responded Tom. "We don't want to lose a unique and priceless collection."

I speak with artist Max Ernst and Tom Messer at the reception for Ernst's 1974 Guggenheim exhibition

Even though, as Tom recalls, "we took it on the chin from the art community for all that brocade."

When Justin Thannhauser died in 1976, our lawyer called to ask whether I had seen the will. I said I had not and wondered whether it was any of our business anyway. But the lawyer said that the agreement was unclear and subject to reinterpretation; it was his view that we might be able to get out from under some onerous restrictions, including those red drapes. I was forcefully told that it was the fiduciary duty of our trustees to pursue the matter.

Shortly thereafter, Hilde Thannhauser, Justin's widow, with whom I was on excellent terms, contacted me. She had learned of our lawyers' inquiries, which neither Tom Messer nor I had authorized, and was understandably furious. Despite my entreaties and a visit to her home in Gstaad, Switzerland, I don't think she ever forgave me. In the end, we at the Guggenheim honored the original Thannhauser agreement, and Hilde, for her part, honored an earlier commitment she and Justin had made to bequeath ten additional works, including the museum's first Monet and an important group of Picassos. As Messer's successor, Tom Krens, wrote to me soon after Hilde's death, "Put together with the works from the Thannhauser Collection that

are already in our possession, one must acknowledge that this is the heart and soul of our late-nineteenth- and twentieth-century holdings, and one of the pillars that makes this a great museum. All of the credit for this development must rest with Tom Messer. Justin Thannhauser was a formidable man, and given the strength of Mrs. Thannhauser's views on many topics, it is a credit to Tom's mastery of diplomacy and negotiation that this combined collection is now ours."

A 1974 run-in with Wright's widow, Ogilvana, served as a coda of sorts to the complex Thannhauser legacy. In completing the annex, we closed in the driveway between the rotunda and the monitor building to accommodate a restaurant and bookstore. Ogilvana wrote to the *New York Times* that we were destroying her husband's monument. "It is a harsh fact to accept that a reputable, supposedly advanced cultural group of trustees in charge of a work of art, the Guggenheim Museum, a monument to beauty, would propose to desecrate this landmark by enclosing what was intended to be an open space in order to establish a restaurant." The letter ends with this flourish: "The intrusion of the restaurant at its entrance will be a disaster and disgrace before the world."

My published response countered the thrust of her argument, pointing out that we'd planned two separate projects: one to create a visitors' tearoom (hardly a restaurant) adjacent to the administration building and invisible from the museum entrance, the other to glass-enclose the Fifth Avenue driveway, replacing unsightly car and truck traffic with a more conveniently situated sales desk. Near my letter's conclusion, I wrote, "Our trustees are most anxious to assure your readers and the general public that we are not unmindful of our responsibility to maintain this beautiful building, which Frank Lloyd Wright left us, intact and inviolate." We had no complaints from anyone else.

The last, and greatest, challenge of Tom's career at the Guggenheim was his vision for the museum's overall expansion, a vision that took ten years to realize and wasn't entirely complete until after Tom's retirement.

In 1982 Tom Messer had convinced my fellow trustees and me that we had to initiate an expansion program. The museum's physical limitations had made it increasingly difficult to display a substantial portion of the collection at any one time, to exhibit large-scale contemporary art, or even to adequately house the growing professional staff.

That year Robin Duke, then a Guggenheim trustee, and I visited the offices of the architectural firm of Gwathmey Siegel & Associates to request that they do a study of our needs and furnish a design. We envisioned an addition of six floors to our existing four-story annex on 89th Street so that we could display on a permanent basis priceless works of art that were languishing in storage. The cantilever effect of their proposed addition was necessary to provide us with enough square footage to include all our operations under one roof.

But once the plans were drawn up and made public in the winter of 1985, all hell broke loose. We had expected some of our neighbors, whose view of Central Park would be blocked by the construction, to be upset. What astonished us was the charge of architectural critics that we would be desecrating Frank Lloyd Wright's "monument." Particularly galling to me was hearing this from that cantankerous and difficult architect Wesley Peters. This was the same man, Frank Lloyd Wright's son-in-law, with whom I had worked seventeen years earlier on the previous Guggenheim annex, and who had persuaded me then that the building should be constructed, at considerable extra cost, in such a way that its foundations would sustain additional floors to be added in the future when our needs required more space and when we could afford to provide it.

Imagine my shock, at our initial hearing before the Board of Standards and Appeals (BSA) in June 1986, to find Mr. Peters appearing as the key witness for the opposition, arguing that Frank Lloyd Wright never envisaged a building or tower on that site! Was his nose out of joint because we hadn't chosen him to "complete" the job he had commenced so many years earlier?

Our effort to better serve the public by doubling our permanent exhibition space now turned into an all-out battle. The local zoning board (Community Board #8) approved the plan and, in its advisory capacity, recommended approval by the BSA,

but the vehemence of the opposition, plus adverse comments from some well-known architects, led us in October 1986 to withdraw our application and go back to the drawing board.

Many months later, our trustees approved a more modest design that won over many knowledgeable critics. Gwathmey and Siegel proposed a lower tower with a reduced mass and subdued finish—somewhat similar to the background building envisioned by Wright in 1951. Of course, the reduced square footage meant we could no longer have every facet of our operation under one roof. Storage off site, for example, would mean an added annual operating expense of $200,000. But half a loaf would be better than none.

On June 30, 1987, our remaining opponents once again squared off, arguing that we should go underground—an alternative that had zero appeal for us as a total solution to our space needs because of the

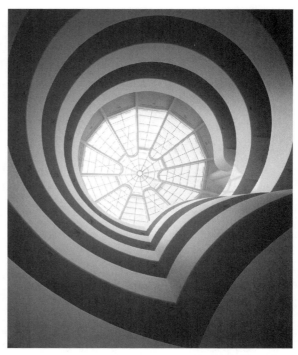

Inside the Guggenheim

added cost and many other reasons. But this time we received favorable comment in the press from most architectural critics and many world-renowned architects, including Philip Johnson, I. M. Pei, Richard Meier, Kevin Roach, Peter Eisenman, Michael Graves, James Marston Fitch, and William Peterson. Was the tide turning in our favor? We thought so. Once again, Community Board #8 had given us overwhelming approval. The climate seemed far better. But now the composition of the BSA had changed. There was a new chairman. How would they vote this time?

On October 20, 1987, the Board of Standards and Appeals ruled, by a vote of four to two, in our favor. The decision was appealed to the Board of Estimate; we won that appeal after six long years and construction finally began.

When I think of Tom Messer, I remember someone with unfailing taste and an authentic passion for art. Urbane, charming, diplomatic, warm, and understanding, he nevertheless had his own clear ideas about how the museum should be run. Under his leadership the museum enlarged its collection in marvelous fashion, highlighted by Thannhauser's works and Peggy Guggenheim's masterpieces, which established our reputation abroad. The growth of the collection and a number of highly regarded scholarly exhibits were triumphs of Tom's directorship.

For his part, Tom kindly credits me with coming to his rescue on several occasions, even before I was president, and siding with him "as much as Peter's basic conviction of the balance between art and business would allow." Perhaps to underscore this point, Tom once took me to lunch at a Wall Street restaurant with the pop artist Jean Dubuffet. During the cab ride back, Tom turned to me and said, "You know, Peter, Dubuffet loves capitalism!" That, indeed, warmed my heart.

Tom and I worked together smoothly and with great mutual respect until his retirement in 1988. As director emeritus, Tom remains highly active as an art consultant, living part of each year in Paris and Spain, as well as New York.

And I hope that when he thinks of me, Tom Messer remembers an easier boss than Harry Guggenheim.

V

COUSIN PEGGY
Return of the Prodigal Daughter

One of Harry's extralegal legacies to me was my mother's first cousin, Peggy Guggenheim, whom I had met before Harry's death but with whom I might never have become well acquainted had Harry not bequeathed to me the financial responsibility for the Guggenheim Museum.

Much has been written by and about Peggy, who amassed a magnificent art collection during her lifetime, mainly from artists in France just prior to its invasion by Nazi Germany. Art lovers around the world know that collection and the palazzo in which it is housed on the Grand Canal in Venice. What is less well known is that Peggy bequeathed her collection and palazzo to the Solomon R. Guggenheim Foundation to operate as it operates the Guggenheim Museum in New York.

Born in 1898, Peggy was the second of three daughters of my great-uncle Benjamin Guggenheim, a bon vivant who effectively abandoned his family for "the high life" of Europe. Peggy was still a young girl when Benjamin went down with the *Titanic* after donning his black-tie dinner jacket so he could "die like a gentleman," relinquishing his place on a lifeboat—and his fur coat—to his mistress. Traumatized by her father's early death, Peggy was also angry at the hypocrisy of having been brought up in a stuffy, status-conscious household that turned out to have been headed by a philanderer. As soon as she was old enough, Peggy began to rebel against her upbringing, moving outward in larger and larger circles from her immediate family and its Victorian constraints.

By her early twenties, Peggy had decided to escape that world entirely. She moved to Paris in 1920 and soon after married Laurence Vail, a dashing, early-blooming playwright who'd grown up with his American parents in France. It was a tempestuous union, described quite harshly in *Murder! Murder!*, a thinly disguised autobiographical account written by Laurence himself. Having borne him two children—a son, Sindbad, and a daughter, Pegeen—Peggy divorced Laurence a mere eight years after they wed.

Meanwhile, Peggy had joined that extraordinary generation of American expatriates and European artists and intellectuals who came together in Paris in the "Lost Generation" after World War I. She met Emma Goldman, the anarchist, anti-war activist, and protofeminist, who was living in exile and poverty in southern France. Peggy befriended Emma, received advice from her (sought and unsought) on topics ranging from marriage to motherhood to politics, and supported Emma for years as she wrote her memoirs.

Peggy also came to know Isadora Duncan, Ernest Hemingway, Jean Cocteau, Ezra Pound, André Gide, and many others—some of them quite intimately. Among her many lovers was the great Irish playwright and poet Samuel Beckett. Peggy's autobiography, first published in 1946, left little to the imagination. Titled *Out of This Century* (and retitled *Out of My Mind* by my mother) the book was critical of her forebears in the United States. Its first American edition received very little publicity, and Peggy once asked me whether, as rumored, my grandfather had bought up all the copies to prevent its circulation. I didn't know. It all took place long before my day.

In 1937, Peggy's mother died and her estate effectively doubled Peggy's wealth, increasing Peggy's ambition to make something more of her life. At about that time she befriended the French artist Marcel Duchamp. As Hilla Rebay had led Solomon Guggenheim to appreciate and support abstract art, Duchamp led Peggy to appreciate and support contemporary artists of many persuasions. (And, as may have been the case with Hilla and Solomon, Peggy and Marcel had an affair.) Up until that point Peggy was, by her own admission, entirely ignorant of the contemporary art of her time. Within several years of befriending Duchamp, she had established a gallery in London. Called Guggenheim Jeune, the gallery opened in 1938, exhibiting the set

Jean Cocteau had designed for his own play, *Les Chevaliers de la Table Rond*, which had opened in Paris the previous year.

Guggenheim Jeune was an immediate success. At Duchamp's urging, Peggy next mounted an exhibit of Wassily Kandinsky's abstract paintings, which was followed by an exhibit of sculptures by Arp, Brancusi, Alexander Calder, and Henry Moore. Several highly acclaimed shows later, Guggenheim Jeune closed in 1939. Peggy had been credited by then with introducing a critical mass of British men and women to the art of their own generation.

In the knowledge that a commercial gallery was financially unsustainable, she tried to create a museum instead and convinced art historian Herbert Read to draw up a list of "musts" that such a museum would include. Between Read's list, Duchamp's affectionate guidance, and her own new motto of "buy a picture a day," Peggy rapidly amassed her spec-

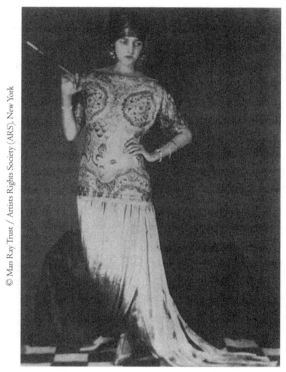

© Man Ray Trust / Artists Rights Society (ARS), New York

Peggy in 1924, photographed by Man Ray

tacular private collection of surrealist and abstract art. As the German army rolled toward Paris, Peggy bought (and thus perhaps saved from destruction) fifty pieces, including works by Brancusi, Dali, Giacometti, Braque, Klee, Magritte, Man Ray, Miró, and Mondrian. She retreated with them to the mountains of Grenoble, where officials agreed to hide them in the local museum's basement.

From Grenoble, Peggy paid for the travel papers and expenses that enabled André Breton and Max Ernst to escape to the U.S. She helped Ernst secure and send some

of his sculptures to America as well. In return, he gave her one of his paintings, the first of several he either gave to Peggy or sold to her at very low prices. Over the course of their relationship she acquired some extraordinary pieces directly from Ernst. In the end, Ernst, the Breton family, Laurence Vail, Vail's new wife and their children, and Peggy, Sindbad, and Pegeen ended up on the same plane to New York together.

There Peggy married Max Ernst, and he and Breton helped Peggy continue to collect. In 1942, she established a new museum and gallery called Art of This Century. Another enormous success, the museum did for New Yorkers something akin to what Guggenheim Jeune had done for Londoners. Besides displaying works of Ernst and other European artists, Peggy's wartime New York shows included American artists from Robert Motherwell to Mark Rothko to Jackson Pollock. Peggy commissioned several major pieces from Pollock, allowing him to quit his "day job" as a janitor in Solomon Guggenheim's Museum of Non-Objective Painting.

Though Art of This Century lasted twice as long as Guggenheim Jeune, it was still a short-lived venture. Having divorced Max Ernst before the end of the war, Peggy moved back to Europe as soon as she could, settling in Venice, where she bought an unfinished eighteenth-century palazzo, Venier dei Leoni, on the Grand Canal and transformed it into a museum for her art and a home for herself.

Much of her life from that point on was something of a denouement that seemed to draw more attention to the famous people she entertained, and the lovers she took, than to the extraordinary work she had done for the world of art.

The reader may wonder why I had not made Peggy's acquaintance, or even heard much about her, before I joined the Guggenheim board. The fact is, my mother's generation of the Guggenheim family was nowhere near as close as the previous generation had been; though first cousins of nearly the same age, Peggy and my mother had very little in common. Mom was certainly no angel, but she was proud of the Guggenheims for their financial success, while Peggy scorned them as conservative and business-

oriented. My Aunt Eleanor, Countess of Castle Stewart, never liked Peggy because as a child Peggy made fun of her dwarf sister Gertrude. Then, too, Eleanor was conservative morally, though liberal politically.

In any case, by the time I met her Peggy had become relatively conservative herself, mainly concerned with her health, her offspring, and her art collection. As Tom Messer put it, "The former enfant terrible now seemed rather naïve and vulnerable."

Our first encounter took place at the Guggenheim in 1969 at the gala opening of the first New York showing of art from Peggy's own collection. Harry, then in his last years as president of the Guggenheim Foundation, had been largely responsible, along with Tom Messer, for persuading Peggy to show her collection at the Guggenheim. Indeed, Tom had known Peggy since the early 1950s, when he had visited her in Venice and purchased a painting by one of her protégés (a piece he eventually donated to the

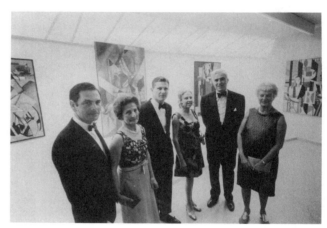

Michael Wettach, Mom, me, Joan Van de Maele, Oscar Straus, and Peggy at the gala opening in 1969

Guggenheim). From his early days as the New York museum's director he had engaged Harry in conversations about Peggy's collection and its potential.

In any case, Harry was ill that evening, and it fell to me to welcome Peggy officially at a small dinner in the president's office before the grand opening. She arrived in New York from Europe barely hours before the event was to begin. Much of her luggage had been lost in transit, so she had only boots to wear with her evening dress. None of it mattered. "How well I remember when she entered upon the ramp," recalls Tom Messer, "and took a look at her works hanging in Solomon

Guggenheim's building. A poignant moment for her. A moment that she never forgot, for it was the instant in which she was persuaded to return to the bosom of the family, with the dowry of her collection and the Palazzo Venier dei Leoni."

That exceptionally successful show led to an agreement, negotiated by Harry, under which the foundation would become custodian of Peggy's Venice palazzo and collection after her death. While visiting my mother afterward in South Carolina, Peggy wrote Harry to tell him "how happy I am that you have accepted to look after my collection after my death. It is a great weight off my mind. I have been worrying for years about the future and now that it is settled I am overjoyed."

Peggy's Palazzo on the Grand Canal in Venice

"Let me assure you how much you have warmed all our hearts," responded Harry. "The progeny of Meyer [Guggenheim] have indeed teamed up to promote the public's interest in the better things in life. I am sure you will never regret [your decision]. When I am not here, as I am sure you know by now, Peter will carry out everything we have planned."

Much has been made of Peggy's early reluctance to enter into such an agreement, but in fact the Guggenheim trustees themselves had initial doubts about the wisdom of assuming such an awesome responsibility. While Harry prevailed and the board approved accepting Peggy's collection, the question immediately arose: how would we pay for its upkeep?

One of our first actions when we assumed active responsibility for administering the collection was to establish an advisory board consisting of friends of Peggy and collectors, business leaders, and art enthusiasts from all over the world. Tom Messer recommended that Mme. Claude Pompidou (whom he knew through their mutual

membership in the Kandinsky Society) be named the group's honorary chair. Mme. Pompidou readily accepted, and today the board includes almost sixty members who meet twice a year—once in Venice and once elsewhere (London, Luxembourg, Paris, New York, Madrid, Hong Kong, or Berlin, among other places). When we decided to expand by purchasing a building and garden behind Peggy's palazzo, the group contributed millions of dollars to the project. These wonderful supporters, under the very able directorship of Philip Rylands, who has been in charge there for more than twenty years, have had much to do with our success in Venice.

The reconciliation between Harry and Peggy spilled over to my mother. They hit it off very well, according to both of them. It was also the beginning of a warm relationship between Peggy and me that continued until her death in 1981. When I succeeded Harry as president of the foundation, I assured Peggy, by then a suspicious and somewhat cynical woman, that her wishes as to her collection at her death would be scrupulously carried out. Many times in the succeeding years she sought my reassurance that our promises would be honored for all time.

Over the years, Dede and I visited Peggy several times in Venice, sometimes staying in her palazzo, where we became acquainted with her son Sindbad, his wife Jacqueline, and their beautiful daughter Karole. Peggy would take us on jaunts through the canals of Venice in her luxurious gondola—rain or shine, since she was committed to paying her gondolier—and seemed to derive great pleasure from arranging for me to get a discount when we dined at Harry's Bar, where she was well known.

One trait Peggy shared with my mother and grandmother was thriftiness concerning trivialities. As did Grandma Guggenheim, Peggy would refold used napkins and spring them on subsequent dinner guests. I experienced this when, with Dede, I visited her in Venice and was revolted to discover egg yolk on my beautifully folded linen napkin. Another example of her concern over expenses was her habit of penciling a line across a partially consumed wine bottle in order to check on whether someone in the kitchen was imbibing. My guess is that her servants probably drank more expensive wine than she did. While visiting Peggy in Venice, her grandchildren were astonished by the scarcity of food in the kitchen and frequently, following the evening meal, dashed off for a pizza.

Returning from one such visit, I met Peggy's former husband, Max Ernst, whose works the Guggenheim was featuring in a major exhibition. Introduced to him by Tom Messer, I remarked quite proudly that I had just seen Peggy at her Venice palazzo—to which Ernst responded with a bit of a twinkle, "Peggy? Peggy who?"

In my business dealings with Peggy I had to walk a tightrope, trying to comply with her desire for us to pick up innumerable expenses in connection with the collection while also husbanding our foundation's funds. Over a period of years we restored many of her paintings, installed a security alarm system after the theft of some of her works, and repaired flood damage to her palazzo.

Although Peggy clearly enjoyed the notoriety her collection brought her, I think she had been let down so often by trusted friends—including husbands—that she yearned to find someone with no ulterior motive. In negotiating with Harry, Peggy was so adamant that her art would remain in Venice that she scribbled a P.S. in longhand on the official agreement: "If Venice should sink, I still want my collection to be kept in the Venice area."

I tried hard to earn her trust and am gratified that I apparently did. As our relationship blossomed over the years, she confided in me more and more about her health and her family concerns and seemed genuinely to trust me. I am told by Angelica Rudenstine (a former curator of the Guggenheim Museum and a scholar of the Venice collection) that Peggy had complete faith in me and was comfortable with her decision to entrust the collection to the foundation because of our warm, familial relationship and my sympathetic handling of her concerns.

One endearing episode I recall was her letter to me of September 1, 1979, asking me for "some written assurance that you will have my dog cemetery left intact after I die. You may not know that I had sixty dogs born here in the house and a lot of them are buried in the garden with a tombstone bearing their names and dates. The last one died a few weeks ago and I am particularly keen on having the tombstones left with the bodies. I rely on you to see to it that Messer does not remove the stone."

I assured her that Tom Messer was a man of total integrity, and that her dog cemetery would remain undisturbed "long after you and I are gone." I was surprised,

upon her death, to learn she had not been completely reassured, and had arranged for her ashes to be placed next to the dog cemetery so future generations would be forced to respect her wishes.

As her confidence in me grew, Peggy sought my guidance on a variety of concerns, particularly as regarded Sindbad who, in 1975, became quite ill. In December 1975, she wrote, "Since he is almost completely dependent on me, I and he would like to know what would happen if I died suddenly, . . . whether all my trusts would pay him . . . immediately or he would have to wait for the rest of my estate to be settled." A quick call to Morgan Guaranty Trust Company, which handled several small trusts in her behalf, provided me, and I her, with the desired assurance.

Peggy at her palazzo in 1979

In early January 1977, having been ill herself, Peggy wrote to thank me for my "kind offer to come to Texas to hold my hand, as you called it. I was quite overcome by your extreme kindness. It was such a lovely thought and I am sure you would have done it if it had been necessary. Instead I went to Vienna where there was a specialist in my disease who decided not to operate and gave me injections, exercises, and medicines instead. I am very happy he did not operate even though I am [only] partially better. The operation sounded rather terrifying." She later asked if she could be put under the Guggenheim Foundation health insurance program since she had no health insurance and was requiring treatment on an accelerating basis. I hated to tell her this would be "impossible, illegal, and unworkable. . . ."

In May 1978, Peggy wrote me that she was "rather worried, if I should get a stroke and could not sign any more checks, what would happen to Sindbad, to say nothing of myself. Not that I would want to be kept alive but I suppose hospital bills

would have to be paid. . . . I have just had a heart attack so I am getting a bit worried. Hate to bother you this way but I need so much your help." I recommended she give her son Sindbad the power of attorney, which she did. Her preoccupation with her health was further evidenced by a letter to me dated May 21, 1979, expressing her sympathy over my mother's stroke: "It seems so strange that I have been so ill for years and am still more or less surviving that this should happen to your mother who never was sick before."

In the last letter I had from Peggy, November 4, 1979, she wrote, "I was rereading the January 27, 1969, letter to Harry Guggenheim and see that under 2C it states that my bedroom should be kept intact with my collection of earrings. This must be changed since I have already given my earrings to my grandchildren." She died the day before Christmas that year, at eighty-one, after a severe stroke.

Peggy and her son Sindbad had what struck me as a love-hate relationship. He is quoted (in various books about his mother) as being extremely negative toward her, but he always spoke warmly of her to me. The day we officially opened the Peggy Guggenheim Collection in Venice in April 1980, I made a speech in the palazzo garden generally extolling her virtues but including, as an illustration of her captivating personality, my experience at Harry's Bar with Peggy and her granddaughter Karole, when she asked Karole not *whether* the boys and girls had affairs on her college campus but *where*. Although the brief tale seemed well received by the audience, Sindbad later admonished me for making fun of his mother so soon after her death. In point of fact, her grandchildren have told me Peggy was obsessed with sex and that she presumed they were fornicating when they were in their early teens—too young to understand her questioning of them on the subject.

Sindbad's understandable anger at Peggy's having left the bulk of her estate to her uncle Solomon's foundation was difficult for him to conceal. Several years after she died I invited him to serve on the Peggy Guggenheim Collection board as an honorary member; I received this letter in response:

25 March 1985

Dear Peter,

Thank you for your letter dated 15 March 1985. I am indeed honoured to be invited to become an Honourary Member of the Peggy Guggenheim Collection Advisory Board, and I accept with pleasure. Truthfully I was always upset that Peggy G. did not stipulate that I be connected with the Collection in some way. Am I supposed to do anything? If so what?

I was thinking of coming to Venice for a week when the palace opens up again at Easter time, but as there is to be no official opening in the end I felt too depressed to go and see what's happened to the place. It all sounds so commercial.

Perhaps Karole told you when you saw her in Venice earlier this month that I was rather irritated about the "Tauromaqui" exhibition. I do not see what this show has to do with my mother in any way. I would be interested in your comments. Also I hear that the front of the Palace is adorned with a long lettering proclaiming what the palace now is. I find that most vulgar, but I have a sneaking suspicion my mother would approve. Her taste was not always conservative.

Anyway Peter, I hope my remarks have not offended you, perhaps I have natural twinges of resentment and jealousy which occasionally arise.

Thank you for honouring me the way you have. I do appreciate it.

We received a very sweet letter from Peter II and Wendy sent us a lovely book on 100 works by Modern Masters from the Guggenheim Museum. Julia will be here soon and we will pass on the photos and family tree to her.

Peggy V. joins me in sending you and Dede our very fond regards.

With love
Sindbad Vail

Pegeen, Peggy's daughter who committed suicide in 1967, had four sons who were not treated with particular generosity by their grandmother. Years after Peggy's death, three of them brought a suit in a Paris court against the Solomon R. Guggenheim Foundation that claimed we had not lived up to our agreement with

Peggy, were poor stewards of the Peggy Guggenheim Collection, and should pay them one million dollars for the mental anguish they had experienced as a direct result of our poor performance.

Hoping to put a stop to the lawsuit and the unfair publicity the boys were generating in the press, museum director Tom Krens and I, with the help of his extraordinarily talented staff members in New York, developed a strategy of attempting to be responsive to their concerns without impeding our fiduciary responsibilities. I made a special trip to London to discuss the matter with the three complainants in an effort to reach some sort of accommodation. The letter that follows, drafted with the help of our lawyers, demonstrates how we attempted to handle the unfortunate episode:

November 4, 1991

David Helion
Nicolas Helion
Sandro Rumney

Dear David, Nicolas and Sandro:

I was pleased that you were able to make the journey to London so that I could hear your concerns firsthand. While I was deeply saddened to hear you describe your reasons for feeling increasingly estranged from the Peggy Guggenheim Collection over the last twelve years, I was also encouraged that we were able to speak so openly. I am hopeful that we can satisfy your concerns amicably. I only wish we had held such a meeting prior to your recent actions, as in many ways I felt I was hearing your concerns for the first time.

At the conclusion of our London meeting, you summarized your concerns in several points and suggested that if we did not respond to these by 4 November 1991, you would file a formal complaint, which is now being translated in New York from French to English for our careful consideration. It appears that this document raises substantial additional requests beyond the scope of our discussion in London.

As I indicated to you at our meeting, the Solomon R. Guggenheim Foundation cannot formally respond to your requests within a one-week time frame. I hope you can understand that I must carefully discuss this situation with various members of our staff. If you could indulge us for a few more days, however, I can promise you a carefully considered response by the end of this week—by Friday morning, 8 November. On behalf of the foundation, I can say that we sincerely wish to have a better understanding of your concerns and we hope we can allay your misgivings about our management of Peggy's collection.

Please understand that while personally I would like to gain your support, as President of the Foundation I cannot abdicate the legal responsibility which Peggy Guggenheim granted to the Solomon R. Guggenheim Foundation. We are all bound by the fact that Peggy entrusted the Foundation—not her progeny—with the stewardship of her collection and palazzo. Our response to your concerns will have to take this fiduciary responsibility into consideration.

Nevertheless, your observations and suggestions regarding our care and presentation of the Peggy Guggenheim Collection are important to me. I sincerely hope our meeting in London will open up better communications between us and make you feel comfortable about your heritage as grandsons of a unique and wonderful woman.

I want to reiterate that I had not only a great affection for Peggy but a warm and close relationship as well. I believe she trusted me to carry out her wishes after her death. On behalf of the Board and other family members, I would like you to know that it has always been and remains our firm commitment to maintain and preserve Peggy Guggenheim's collection in Venice in keeping with her wishes.

No matter how this controversy turns out, I will always remember your heartfelt presentation in London, which touched me very deeply.

Very sincerely,
Peter Lawson-Johnston

Our effort to meet the grandsons halfway proved fruitless, and they pursued the case in a Paris court. Peggy's other grandchildren refused to join their cousins in the suit. Although several of our trustees urged me to settle, I believed such a course of action would have been unconscionable in view of the unwillingness of Karole Vail,

and her sister Julia Vail and half-brothers Clovis Vail and Mark Vail, to join their cousins' endeavor to sully our reputation in Venice, even though they had, from time to time, qualms about our administration.

Many months later, after we had obtained innumerable testimonials regarding our stewardship, the court reached its decision. On December 7, 1994, the Tribunal de Grande Instance de Paris issued a decision representing a complete victory for the Guggenheim Foundation. The court assessed legal costs against the plaintiffs of 30,000 francs.

That my three cousins would attack us came as a terrible shock to me personally and caused me considerable anguish. I had great affection for Peggy and truly believe she would be enormously pleased with our stewardship if she were alive today. I would never permit our foundation to betray the trust she had in me to carry out her wishes for the collection's safekeeping.

During the traumatic period of this confrontation I was buoyed by the support of Karole, Julia, and Clovis. Through them I also came to a clearer understanding of the sense of disenfranchisement that had led their cousins to press this case, and to then appeal the court's decision.

Finally, however, in December 1996 a settlement was reached with Peggy's grandsons whereby a Peggy Guggenheim Collection Family Committee was formed that included the Vails. I was pleased and flattered that the grandsons insisted I be the one to sign the settlement agreement on behalf of the Solomon R. Guggenheim Foundation. I am particularly grateful to Karole Vail, who now works at the New York Guggenheim. In 2003, Sandro Rumney and his wife Laurance hosted a glorious "Friends of Peggy" reception at his impressive office in Paris, and I knew for certain that this particular piece of our past was well behind all of us.

The Peggy Guggenheim Collection is an oasis of twentieth-century art surrounded by a city of ancient artifacts. My cousin Peggy must look down upon us with enormous satisfaction because we have a fabulous record of stewardship of the enterprise.

VI

TOM KRENS
Toward a Global Guggenheim

My most controversial decision regarding the Guggenheim was to follow the advice of Tom Messer in choosing his own successor. In 1988, having determined that twenty-seven years as director were simply enough, for him and for the museum, Tom announced his resignation. He strongly recommended a highly unlikely candidate to take his place: the head of a small college museum in the northwest corner of Massachusetts.

Tom Krens's accomplishments as director of the Williams College Museum of Art (WCMA) had spread far beyond the confines of that bucolic campus of 2,000 undergraduates bordering Vermont and upstate New York. Krens had come to his Williams position with unusual credentials and via a winding path. A Williams undergraduate from Syracuse, he majored in political economy with an idea of entering business. Inspired by several art courses he took in his senior year, however, he changed direction entirely. When he graduated in 1969, he moved to Geneva, Switzerland, and apprenticed himself to a printmaker.

A year later, he returned to take a master's degree in studio art from the State University of New York at Albany. Having secured that credential, he was invited back to Williams to teach printmaking. Signs of his undergraduate major—and of the arc of his future career—could be seen soon thereafter when he formed an upscale t-shirt company with a few of his students. Retailed through New York City boutiques and museums, the t-shirts sold so well that the company outgrew its

original headquarters in a Williamstown barn to fill an abandoned factory in nearby North Adams.

Not long after Tom settled in at Williams, he was invited to join an informal study group founded by Mark Taylor (now Williams's Cluett Professor of Humanities) and the renowned teacher and scholar Cornel West. (Professor West was then a visiting professor at Williams; he is now Class of 1943 University Professor of Religion at Princeton. We at the Guggenheim elected him to a term on our board some years after Tom became our director.) This group of Williams professors met weekly for informal but intensive discussions on the poststructuralist scholarship that was beginning to make its way from Europe into American academe. Taylor's first impression of Tom—one he says has proven accurate over time—was that Tom was *really* smart: "Smart enough," says Taylor, "to understand this poststructuralist stuff better and faster than we PhDs."

Tom was soon teaching Williams students art history as well as studio art; he was also teaching a course he'd developed called "Contemporary Strategies for Art and Criticism." When the college began to plan a major expansion of WCMA, Tom was asked to serve on the building committee. Midway through the project, WCMA's director abruptly resigned, and—in large part because Tom had been an outspoken committee member—Williams's president, John Chandler, asked him to lead the project. The existing museum consisted of a series of small rooms of more-or-less identical scale and style. It seemed to Tom that all those little rooms weren't suited to the program Williams's art department was trying to realize, so he worked with the renowned architect Charles Moore to create an entirely new museum model—a series of rooms, each of which offered a unique spatial experience.

This new WCMA vision was more costly than the college had originally envisioned, but Tom convinced a principal benefactor, the artist Maurice Prendergast's widow, Eugénie Van Kemmel, to support the project. Pleased with her support and agreeing with Krens that there was value in building a more broadly cultural institution on Williams's campus, President Chandler offered Tom the directorship of the Williams College Museum of Art in 1979.

To equip himself to realize his ambitious vision for the museum, Tom began to

augment his "day job" with work on a second master's degree—this one from the Yale School of Management. It seems telling in retrospect that Tom's Yale master's thesis was on the Getty family and, in part, its deep and productive involvement in the world of art.

Applying what Yale had taught him about marketing and finance, Tom presided over exponential growth in WCMA's programs and attendance levels through the 1980s. As Grace Glueck wrote in the *New York Times*, this expansion transformed Williams's museum from "a pokey teaching institution to a glamorous showplace for international art."

As WCMA grew, Krens came to the attention of Tom Messer, who in addition to his Guggenheim duties served as president of the Association of Art Museum Directors. Messer was particularly impressed by a 1983 study conducted by Krens for the Brooklyn Museum—a study that revealed, in hard-hitting financial terms new to the museum world, that the Brooklyn Museum was largely understaffed and underendowed.

Soon after the new WCMA building project was complete, Krens took a trip to Cologne where he came across a group of artists who were exhibiting their work in an abandoned factory. It hit Tom that he was sitting in a valley of abandoned factories back home. North Adams, a once-thriving manufacturing center next to Williamstown, had by the 1980s lost most of its factory jobs, leaving behind the abandoned husks of massive nineteenth-century mill buildings. Tom's first idea was to employ some of this space as a WCMA annex, but the more he thought about it the more he realized that many leading contemporary artists were producing works so large that they were impossible to squeeze into crowded museums in major metropolitan areas. North Adams had loads of space, cheap space at that, and was desperately in need of a postindustrial economic boost. What if both demands could be met through a major new museum of contemporary art situated in North Adams?

Thinking to create the new museum as a public/private venture, Krens courted government officials from the mayor of North Adams to Massachusetts Governor Michael Dukakis. "We became political players," he recalls, "meaning we learned to

talk not about art but about jobs." One of Tom's former Williams students, Joe Thompson, joined him in the start-up effort, which eventually grew to a budget of more than $30 million. An economic downturn in the late 1980s stalled public-sector support, but in the end—aided by millions of dollars in gifts from private philanthropists—the Massachusetts Museum of Contemporary Art (MASS MoCA) finally opened in 1999. It has earned national recognition in its early years of operation as a vibrant center for the visual and performing arts.

In these and other ways, Tom Krens was developing a wide reputation for getting things done. We at the Guggenheim asked him to serve as a consultant to our planned museum expansion. I was immediately struck by his administrative skills, as was Tom Messer, who saw in Krens the managerial and entrepreneurial experience that would help the Guggenheim through "the Perils of Pauline" of permits, approvals, and fundraising necessary to make our expansion succeed. When Messer announced his retirement, he urged us to hire Krens.

I visited Tom in Williamstown soon thereafter. I liked him immediately; he was clearly a logical thinker—very thorough and very articulate. After showing me around WCMA, he drove me out to the abandoned mill complex that would someday become MASS MoCA. I remember thinking: "This guy's *got* to be a visionary, because I sure can't see *this* place as a museum." In the end I was deeply attracted by Tom's fresh view of the larger role of museums in the coming decades, and I recommended to our trustees that we make him the Guggenheim's director.

It turned out Krens was also under active consideration by the San Francisco Museum, so we were obliged to keep quiet the Guggenheim's interest in him. I sensed Tom would prefer leading the Guggenheim, and I was right. As Tom himself put it, "If you take culture seriously, it's either New York or nothing, and there are only three available New York platforms: MoMA, the Whitney, and the Guggenheim. I saw the Guggenheim as an evolving investigative device for understanding how culture works and how it's used, so I made myself available."

As we negotiated his compensation, Krens requested an incentive arrangement—unusual if not unprecedented in the art world. With some difficulty, I convinced my fellow trustees to agree to this form of remuneration contingent on performance.

Tom accepted the Guggenheim directorship in 1986, though his commitments to Williams and MASS MoCA delayed his arrival in New York until 1988. That delay caused some initial confusion and friction. A *New York Times* article implied that Tom's main focus might continue to be MASS MoCA rather than the enormous challenges facing the Guggenheim in both New York and Venice. Provincial New Yorkers, of course, feared a major museum in their city might become an appendage of some project in the boondocks of New England. I suspect that if the abandoned factory had been in the Bronx, the local reaction might have been more favorable.

At my urging, Tom defused the controversy at our next board meeting by enumerating all the potential benefits to the Guggenheim if we were at some point to become loosely associated with a successful MASS MoCA: for example, the possibility that we might acquire important works too large for the Guggenheim to accommodate in New York. He convinced us that MoCA was the sort of project an institution such as ours ought to consider seriously, forcing us to face the future more directly and actively than we had done before. We were reminded that in choosing this future-oriented director we had invited just this kind of healthy confrontation. In the end, the Guggenheim and MASS MoCA essentially and amicably went their separate ways, but MoCA has housed and exhibited some of the larger pieces in the Guggenheim collection.

From the day he arrived, Tom faced considerable challenges at the Guggenheim, not least of which was the gap between the museum's traditional aspirations and where we were headed in the late 1980s. He rightly understood that the board and I looked enviously at MoMA and the Whitney, which had both just expanded—and at the benefits accruing to those two museums as their respective resources multiplied.

Catching up meant ensuring, first and foremost, that the Guggenheim facility was up to our own evolving ambitions. Having inherited from Tom Messer the blueprints and zoning approvals for the Guggenheim's new addition, Krens convinced us that we needed an even larger expansion than initially envisioned and that the original

museum building required extensive restoration. In sum, the overall cost would be three times greater than our board had anticipated.

Unlike MoMA (backed by the likes of David Rockefeller) or the Whitney (backed by the likes of Leonard Lauder), the Guggenheim had no readily available resources to cover these additional costs. Instead we were forced to borrow $55 million. The bonds were issued by the Trust for Cultural Resources of the City of New York, a corporate governmental agency and public benefit corporation. (Many other museums and educational institutions have issued similar bonds through the trust. None of the assets or income of the Solomon R. Guggenheim Foundation or any of its affiliates serve as collateral or other security for the bonds.)

On June 22, 1992—when the newly enlarged and renovated Solomon R. Guggenheim Museum was rededicated—the glorious response engendered by the project made the financial stretch seem worth every penny. "The Liberation of the Guggenheim" was the main headline of Paul Goldberger's pre-opening review on the front page of the *New York Times* "Arts & Leisure" section. Its subhead: "This is one of the few buildings capable of making the heart beat faster." The result," wrote Mr. Goldberger, "possesses not only a beauty and a power beyond what this building has been able to communicate over the last generation but also a purity; it is no exaggeration, I think, to speak of the whole process as a kind of purifying ritual for the Guggenheim. . . ."

The decisive, uncompromising style that has characterized the Krens era was evident from the start. Soon after joining the Guggenheim, he concluded a deal with Count Giuseppe Panza di Biumo to acquire 350 contemporary works. These minimalist, conceptual, process, and environmental art pieces, principally by American artists of the 1960s and '70s, constitute an essential representation of the period. To buy them, Tom sold three major works from the Guggenheim's permanent collection—a move that certainly led to some criticism. However, our board had approved the deal, after carefully weighing the pros and cons, because we believed the Guggenheim

collection must encompass *all* twentieth-century art. Indeed, the fact that we were expansion-minded had much to do with Panza's decision to deal with us.

A more aggressive approach to acquiring, lending, and selling art had been part of Tom's vision for the Guggenheim from the start. Unlike other countries' museums, which enjoy substantial government subsidies, American museums must behave like other American enterprises in order to flourish. In other words, they need to grow. Although the jury is still out, Tom believes (and I concur) that domestic and foreign expansion can surmount the financial problems facing institutions such as ours. With the growing flagship museum in New York and Peggy Guggenheim's palazzo on the Grand Canal in Venice, the Guggenheim was well positioned to seek global support for its programs, collections, and name. Tom further sustained our international position by continuing to appoint prestigious European curators. He also organized scores of traveling exhibits that went to Europe and Asia.

Madame Claude Pompidou, honorary chairman of the Peggy Guggenheim Collection advisory board, and I visit Queen Sofia of Spain at the Royal Palace in 1991

As the Guggenheim began to attract international attention, I was visited by an Austrian doctor named Felix Unger, who told me he was fascinated by the Guggenheim in Venice and dreamed of a Guggenheim Museum in Salzburg. I politely demurred, but he kept pursuing me to the point where Tom and I agreed to meet him in Venice. After that encounter, Tom and I agreed that we had our hands full with the expansion project, and so we dismissed the idea. Undeterred, my new Austrian friend approached us once again, but this time he brought with him a rendering by the architect Hans Hollein of what he and other Salzburgians thought their museum might become.

The image showed a glass-domed circular museum embedded in a towering hill in the city's center. The concept of carving out of a small mountain a museum similar to the New York Guggenheim was irresistible. We agreed to collaborate with the Austrians on the project. A feasibility study ensued, and there was much publicity about the project for years afterward. In the end, though, the project fell victim to politics. When the Iron Curtain came down, Austria was overrun with immigrants who brought enormous costs to the country. That and the fact that Salzburg's city administration was run by officials of a different political party than the federal government doomed the project.

Nevertheless, the news was out that the Guggenheim was seeking to broaden its international reach. Publicity about the Salzburg project reached as far as Bilbao, Spain's fourth largest city, located in the Basque Country. Having prospered until the mid 1970s from iron ore, trade, shipbuilding, and heavy manufacturing, Bilbao had entered a prolonged economic slump. Eager to diversify the city's economic base, city fathers had embarked on a $15 billion redevelopment plan. They hoped to anchor that plan with a world-class museum to erase Bilbao's stodgy image and help attract tourism. In 1991, Tom Krens was approached by the Basque government with a proposal that our foundation enter into a joint venture to operate a modern and contemporary museum in Bilbao.

Joking that "terrorism and jai alai" were all he knew about the Basque Country, Tom's first inclination was to turn them away politely. The Basque officials were persistent, however, and eventually Tom traveled to Bilbao. The city's officials showed him a building they had in mind, one in the heart of the city. Still cool to the entire idea, Tom found this locale totally unacceptable. But the following morning, as he jogged along the Nervion River through a rundown waterfront, the idea came to him of building a museum in that location—a museum emulating the famous opera house on the water in Sydney, Australia.

Tom's attitude shifted from skepticism to total enthusiasm. He sought support from those of us on the board to enter into an agreement whereby the Basque governmental entities would provide the funding and the Guggenheim would provide the expertise and art, on loan from its own collection.

Tom urged me to go over and meet with the Basque government myself. In September 1991 I flew to Bilbao with Robert "Stretch" Gardiner, a fellow trustee and vice president of our foundation. Stretch and I were treated royally by our Basque hosts, who literally rolled out the red carpet, provided each of us with an interpreter, and helicoptered us all over the countryside. Bilbao's mayor took us to a water light show performed to musical accompaniment. One of the highlights of our three-day visit was a trip to a vineyard where, in an elaborate ceremony, we commemorated a special wine named "Guggenheim," which would be uncorked at the museum's grand opening.

Stretch and I were enraptured with the whole enterprise and on our return to New York reported to the board that the venture should proceed. Our trustees voted unanimously to support this trailblazing endeavor, which we were all confident would have a favorable impact on the Guggenheim as well as on the Basque Country.

After prolonged negotiations with three levels of Basque government, Tom Krens hammered out an agreement whereby the city of Bilbao donated the land for the site and the Basque Country and the province of Biscay provided the capital and operating funds for the museum—specifically, $100 million for the construction of what was to be named the Guggenheim Museum Bilbao, and $50 million for an ongoing, major art acquisition program and guarantee that any operating deficit would be covered. Furthermore, the Basques paid the Guggenheim a one-time, $20 million fee, in addition to various other management fees, for the use of our name and for our participation in the museum for twenty years. The Guggenheim would oversee the design of the museum building and control the art program, subject to budgetary review from Bilbao. To spend the public's taxes on such an endeavor demonstrated enormous political courage by the party in power.

We set up a joint committee to choose an architect and held an international competition. With strong lobbying by Tom Krens, the committee chose the world-renowned Los Angeles architect Frank Gehry to design the new museum. Gehry's challenge was to design a museum on the banks of the Nervion, which would be the epicenter of the grand design of the Basques to change the image of Bilbao from a "rustopolis" to an international tourist destination. Gehry credits Tom with the success of the entire Bilbao enterprise, including Tom's ideas for important architectural

features, among them a huge atrium reminiscent of the New York Guggenheim and a gallery bigger than a football field. (The latter now houses an enormous Richard Serra piece.)

I made several more trips to Bilbao as the museum evolved, one of them to greet Spain's king and queen, who called the museum "the greatest building of the twentieth century"—a view shared by the legendary architect Philip Johnson, who visited the site during construction. I returned to Bilbao two years later, in October 1993, to participate in the groundbreaking ceremony, joining José Antonio Ardanza, the

Lehendakaria (president) of the Basque Country, in sinking a cylinder containing official documents into the ground for posterity.

Not until the museum opened in October 1997, however, did I realize what a sensationally successful decision we had made in accepting the responsibility of partnership with the Basques. The favorable publicity that

Dede and I visit with Princess Diana in Venice (in the background is Philip Rylands, director of the Peggy Guggenheim Collection)

greeted the opening of Frank Gehry's masterful building was overwhelming. I particularly cherish this meditation on Guggenheim Bilbao by Laurie Norton Moffatt, director of the Norman Rockwell Museum: "Soaring medieval cathedrals were built to inspire reverence, invite reflection, foster community, educate a populace through art, and create culture enlightenment through religion. As does Frank Lloyd Wright's masterpiece, Frank Gehry's Guggenheim Bilbao sets the soul soaring, and if the art and people it displays feel awed, if not a bit diminished within its towering scale, it serves to remind us that museums are the modern day cathedrals of the soul."

Dede and I took our four children and their spouses to the opening celebrations. We stopped in Majorca on our way and were shocked by news reports that a Bilbao

city policeman had been shot and killed by terrorists outside the new museum's main entrance. Militant Basque separatists disguised as florists had delivered a dozen remote-controlled grenade rockets hidden in potted plants placed near a sculpture by Jeff Koons. The police officer who gave his life foiled the plot, but my family remained a bit apprehensive about proceeding from Majorca to Bilbao.

A large security force, including rooftop sharpshooters, joined us at the October 18 inauguration, which went peacefully and beautifully. The museum officially came to life when King Juan Carlos flicked the main light switch. He and the lovely Queen Sofia joined 600 guests for an elegant dinner in the 450-foot main gallery. Speeches prior to the din-

King Juan Carlos greets Tom Krens and Frank Gehry at the opening festivities for the Guggenheim Bilbao in 1997

ner by leaders of the Basque government reflected their pride in having had the courage to enter into their partnership with a foreign foundation over the vitriolic objections of many of their countrymen.

I remain deeply proud of the Guggenheim's role in this initiative, which created the visual and aesthetic centerpiece of a city that is truly reborn. According to a Bilbao annual report, income for the museum in 1998, its first full year of operation, was up 22 percent against budget. A study by KPMG, the international accounting firm, established that the Guggenheim Museum Bilbao generated 920 million euros in economic activity in the Basque region; produced 144 million euros in local tax revenues (which covered the entire cost of the construction of the museum); created 4,137 permanent new jobs; and generated international media coverage worth in excess of 250 million euros, which led to substantial investment in new businesses in

the Basque Country. More than 5.2 million people have visited the Guggenheim Bilbao since it opened. It's reached a point where people I meet apologize for not having been there yet. Not bad for a city few Americans had even heard of before the Guggenheim arrived.

I am profoundly grateful to the Basque leaders, without whose vision, bravery, and deep commitment Guggenheim Bilbao would never have come into being.

Guggenheim Bilbao's success marked the beginning of a Guggenheim that spans the globe today. A month after Bilbao, Deutsche Guggenheim, our joint venture with Deutsche Bank, opened in Berlin on the ground floor of the bank's headquarters. This unprecedented partnership between an international bank and an "internationalizing" museum was another brainchild of Tom Krens, and its realization the result of his remarkable ability to engage and inspire Guggenheim partners.

We are now in our second five-year agreement in which Deutsche Bank pays all expenses associated with the museum, including all exhibition costs and costs for original commissions. As with Bilbao, the Guggenheim controls the art program and is reimbursed for all out-of-pocket expenses. We also have a one-half interest in all the commissions, which to date include works by James Rosenquist, Jeff Koons, Bill Viola, and Gerhard Richter. The museum hosts some four major exhibitions each year, featuring internationally acclaimed artists and young up-and-comers.

Soon afterward, Tom established a similarly innovative arrangement with the Hermitage in St. Petersburg, Russia, whereby the Hermitage exhibits Guggenheim works and vice versa. Vienna's Kunsthistoriches museum enjoys a comparable arrangement with the Guggenheim.

Merging the cultures of Russia, New York, and (of all places) Las Vegas was the proposal Tom brought to the Guggenheim board in the late 1990s. When he made the case for the Guggenheim Hermitage in Las Vegas, we were at first highly skeptical. We simply couldn't bring ourselves to believe that people who vacationed in Vegas could possibly be the same people who would be interested in modern art

exhibits. But Tom argued that bringing art to Las Vegas would take it out of a context that intimidated non-museumgoers, something that would not only be profitable in Las Vegas but would expand the audience for art nationally. We told him to go ahead.

Tom commissioned Rem Koolhaas to design a museum in two parts, both within the vast Venetian Resort-Hotel-Casino. The first part was a large space, called the "big box," to house large, impressive exhibits. The second was a small "jewel box" to feature masterworks from the core Guggenheim and Hermitage collections. Tom wisely planned to inaugurate the large space with the Guggenheim's record-breaking "Art of the Motorcycle" exhibit (designed by Frank Gehry). Tom believed the motorcycles would lure visitors into the museum space, where many would also explore the jewel-box collection.

Circumstances well beyond our control mean it will take some time before we know if Tom's brave and noble experiment will prove successful. The Guggenheim Hermitage Museum in Las Vegas opened one week after September 11, 2001, and—along with the rest of America's travel and leisure economy—it has struggled ever since. The larger museum space has closed indefinitely, but the "jewel box" is still hanging in there, quietly proving Tom's contention that art holds interest for a great many people beyond the traditional museum-going crowd.

For the last few years, Tom worked hard to establish a Guggenheim Museum in Rio de Janeiro. Designed by celebrated French architect Jean Nouvel, the museum was planned for construction on the site of the Mauá Pier, which extends into Guanabara Bay. The arrangement was similar to Bilbao and would have been $30 million. After Rio's mayor came to meet with us in New York, we were convinced the project was a go. But when he returned home, he ran into grave political opposition, mostly along the lines of, "How can you give the Yankees $30 million when we have hungry mouths to feed?" If only those critics would take a closer look at Bilbao's rising standard of living, they would have their answer. Unfortunately, the prospects for this project are bleak.

More recently, we've agreed to conduct a feasibility study to assess a possible Guggenheim Museum in Guadalajara, Mexico. We've also agreed to participate in a bid to develop an area in Hong Kong designated for major cultural facilities. And

we've taken a look at Tai Chung, a Taiwanese city hoping to establish itself as an international travel destination. (At $199 million, early projections for that project's earnings approach Bilbao's.) Whether it makes sense for the foundation to continue exploring new geographical locations is a matter for the board to decide. We continue to examine each of these projects on the basis of cost-benefit projections.

Perhaps our most global venture of all was our Internet partnership with GE Capital and other corporate investors. Yet another example of Tom's negotiating abilities, "Guggenheim.com" garnered a multimillion-dollar investment from these companies, while retaining for the Guggenheim a controlling stake in the venture. When we launched "Guggenheim.com" we had as many as forty programmers and other employees. Alas, like the vast majority of late-'90s Internet ventures, this one collapsed when the dot-com bubble burst. Its future remains uncertain.

When our global image first evolved in the early 1990s, there was considerable negative publicity, and our pioneering efforts were the butt of jokes throughout New York's highly parochial art world. One newspaper story referred to us as "the McGuggenheim." Ironically, our plans at local expansion were even more ambitious than our global ones. The Guggenheim Museum SoHo was established in 1992 when Tom located cheap space in downtown Manhattan that would allow us to exhibit a greater portion of our large—and largely sequestered—collection. We on the board approved the arrangement, which continued until a post-9/11 drop in attendance forced us to close the downtown operation.

Tom and the Guggenheim's trustees also envisioned a vastly more ambitious project for a museum in lower Manhattan—a complex that would encompass more than 200,000 square feet of exhibition space as well as a performing arts center and several restaurants, all built over several piers where Wall Street meets the East River. In 2000, my fellow trustee Jack Wadsworth committed a substantial sum toward a preliminary study of the project, which at forty stories would have been more than ten times the size of the original Guggenheim Museum, and which would come with

a price tag of as much as $900 million. Frank Gehry was again the favored architect, which at first led me to object to the project. I was concerned that our new Bilbao partners would be chagrined to learn that the architect of their unique city museum was working on a New York building to dwarf their own. But when I shared that concern with the Basques (one of whom had by then been named to the Guggenheim board), they responded that they were wholeheartedly in favor of the New York project. They sensed that the better the Guggenheim name became known around the world, the better for all Guggenheim partners.

That earned my somewhat reluctant endorsement, and we began an aggressive fundraising effort, with board chair Peter Lewis committing $250 million contingent on $60 million in New York City funding and an additional $30 million raised in the initial twelve months of a private fundraising campaign. In the end the horror of September 11 brought our dream, and so many other people's dreams, to a grinding halt. In retrospect, this may have been fortunate. Though funding for the project would all have come from non-museum resources, it seemed out of kilter that the Guggenheim—whose own endowment is some $40 million (well shy of the $500 million required to underwrite its annual budget)—would also be responsible for a $900 million satellite.

Because they are tangible projects with big price tags, all of these Guggenheim "franchise" operations have garnered a lot of press, much of it obsessed with controversy that often obscures great stories about the art acquisitions and exhibitions that have been Tom Krens's more essential Guggenheim accomplishments. (The term "franchise" is itself misleading, incorrectly implying that we have a set formula that we replicate around the world. In fact, each Guggenheim is quite different in terms of its architecture, its program, and the financial structure that supports it.)

Other museum directors are in part responsible for Tom's public image as a director who's focused on matters of commerce and expansion, even—some imply—to the exclusion of art itself. While Tom is the first to admit that in his early

Guggenheim years he found it difficult to communicate his intention and direction, this image is predicated, in part, on a willful disregard for the record. To those who claim, "Krens doesn't like art," Tom calmly responds that he came to the museum from twenty years in the field of art history. "In the last ten years we've added 4,000 objects to the collection, our publishing record during that time is astonishing, and we've mounted no fewer than 121 shows. It's fashionable in art circles and the *New York Times* to talk about Armani and motorcycles, but what about the other 119 exhibits?"

Institutional jealousy is clearly part of the problem. Tom's lineup of curators— from the renowned Picasso scholar Robert Rosenblum to curator of film and video John Hanhardt (whom we lured from the Whitney) to guest curators ranging from Sherman Lee to Walter Hopps—represent the very best. As Tom puts it, "such a concentration of excellence in one place sometimes bugs people; for the Guggenheim to do a China exhibit better than the Met's bugged the Met." Indeed, the Met's director, Philippe de Montebello, habitually refers to Krens as "the tall one." Having criticized the Guggenheim's Armani exhibit, de Montebello soon afterward mounted a Versace exhibit—six months after the clothing designer's death—provoking tongue-in-cheek cries of "necrophilia" from Krens.

All of this institutional envy seemed to have been compressed into an extraordinarily biased June 2002 *New York Times Magazine* article by Deborah Solomon, who condemned Tom for over-expansion, financial mismanagement, and favoring museum buildings over the art they are built to house. She even singled out Guggenheim Bilbao as being inhospitable to art. The *Times* published only one rebuttal letter (by the artist James Rosenquist, who praised Tom Krens for "building museums around the world for future generations of artists" and Guggenheim Bilbao for its "invitation to artists to come and do their thing"). Letters the *Times* chose not to publish included one from the artist Robert Rauschenberg, who wrote that the article "is a disservice to an extraordinary institution and to the major contributions Tom Krens has made as its director. . . ."

No question that Tom is a complicated man, deeply intriguing and sometimes exasperating. He tends not to schmooze much with fellow directors and is therefore perceived as unfriendly. He dominates any meeting he attends, including those with

Guggenheim trustees, in large part because he's brilliant and everyone wants to hear what he has to say. He can talk at length about any facet of the museum. Keeping up with him is a real challenge, as he is constantly traveling. Seemingly impervious to jet lag, he can attend a dinner in Bilbao and make it back to New York in time for breakfast.

Tom marches to his own drummer, and time constraints often restrict his attention to his own top priorities. One never knows what he'll consider important or unimportant, and sometimes intrinsically important items that fail to pass across his radar screen fall through the cracks. Trustee Stephen Swid and I were once wooing a prospective board member—a very wealthy individual capable of contributing millions of dollars to the museum. We met with this person and explained that the next step in the process would be a meeting with Tom Krens—a meeting that never transpired because Tom let it slip. In all fairness, Tom's indiscretions are rarely this grave. They're more of the sort that would irritate someone like me, who's in regular contact with him over clearly important but not deeply essential priorities. Several of my letters to him have gone unanswered, for example, and it took him ten years to change a single job title in order to advance Philip Rylands, the man in charge of Peggy's Venice collection, from "deputy director" to "director."

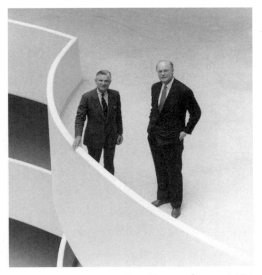

Tom Krens and me in 1992

Additionally, Tom Krens's style is so different from Tom Messer's that, particularly early on, Krens was faulted simply for doing things differently from the way Messer had done them. An art scholar first and foremost, Messer had enjoyed a long and enormously successful career at the Guggenheim by answering Harry Guggenheim's call and then my call: to run a damned good museum, to put us on the

map in terms of acquisitions and holdings, and to mount interesting and important exhibits. Krens, who can certainly hold his own in matters of art history, is more an administrative visionary—someone who takes an infinitely broad view of the entire museum enterprise. This means that museum staff, trustees, artists, and peers used to more direct and frequent encounters with Messer were bound to be disappointed when Krens's focus on additional priorities left less time and attention for them.

Media coverage has relentlessly characterized Krens as "irrationally exuberant" in his management of the Guggenheim, which must be rescued from his spendthrift habits by a patient but increasingly exasperated board of trustees. In response, Jack Wadsworth—former managing partner of Morgan Stanley and former chairman of the Guggenheim Foundation's Executive Committee—offered the following story: In early 2001, when the bubble of the late 1990s had yet to begin its inevitable deflation, Tom Kens came to Wadsworth and board chair Peter Lewis to say he thought the economy was headed south and that the Guggenheim would have to rein in expenses, perhaps severely, in order to avoid serious financial problems. Wadsworth and Lewis agreed and asked Tom to flesh out a plan for cutting costs and reducing or freezing investments in new ventures. Tom did so and met with Lewis to present his plan . . . on September 11, 2001. The rest, of course, is history. The terrorist attacks devastated the New York tourist trade, not to mention the rest of the nation's economy, and the Guggenheim—along with every other major American museum—took a huge hit, but *not* for lack of responsible foresight by its director.

As it turns out, the years since all of that "Guggenheim's sky is falling" publicity have been extraordinarily successful ones for the museum. In 2003 we received three major awards from the U.S. section of the International Association of Art Critics. "Matthew Barney: The Cremaster Cycle" won first place in the category Best Monographic Show Organized in New York City; "Kazimir Malevich: Suprematism" won first place in the category Best Monographic Museum Show Organized Nationally; and "Moving Pictures" won second place in the category Best Thematic Museum Show Organized in New York City. In 2004 two highlight exhibitions— "Constantin Brancusi: The Essence of Things" and "The Aztec Empire"—both garnered rave reviews.

In taking the measure of Tom Krens's Guggenheim directorship it is crucial to keep in mind what many in the art world resolutely refuse to acknowledge: that the management of a museum across the turn of this millennium is in fact more complex than that of most businesses. Indeed, when museums fail to take "worldly" considerations into account, they do great disservice to themselves and to the people they purport to serve. As Rauschenberg, in that same unpublished *New York Times* letter, wrote, Tom's "genius is envied—or not accepted—because of his aggressive ideas to bring art to the world."

Those ideas go back to Tom's days at Williams and the discussion group with professors Taylor and West. In its barest essence, the philosophy adopted by Tom and then shaped to his own professional designs goes as follows: For centuries (at least in the Western world) art has been viewed as distinct from other, more practical human endeavors. Generations of artists, critics, and scholars have shared a deep conviction that the farther away art gets from worldly concerns, the better art gets. (Indeed, one can view the Guggenheim's roots in "nonobjective" art as one outcome of this perspective.) But Tom and a growing number of scholars and critics who look at art in broader and deeper terms see art—particularly in light of a rapidly globalizing economy—as a form of cultural currency, a powerful and growing economic and political force. Indeed, as in ancient cultures when art was inseparable from daily life, art remains, undeniably, a commodity—one that can be packaged, transported, and sold at a profit.

Here's a single, extraordinary example of how powerful this "currency" can be: As the Soviet Union was collapsing, Tom sought to secure an exhibit of Russian avant-garde art for the New York Guggenheim. The habitual avenue for such a venture would be some bilateral cultural organization. Instead, Tom went through the U.S. State Department, which presented the opportunity as one greatly in Russia's interest, as the new country tried to sustain international tourism in the face of vast political and economic uncertainty. Tom closed the deal by convincing Lufthansa to

sponsor the exhibit—in exchange for Russia's granting Lufthansa the first trans-Siberian air rights ever bestowed on a foreign airline. This, of course, gave Lufthansa an enormous competitive advantage over other international carriers.

Museums and other institutions brave enough to recognize art's practical advantages are willing to share more art with more people and in more places than those that continue to behave as if art is a rarified and "priceless" achievement best reserved for the tiny fragment of humanity that inhabits a small set of institutions in a few of the world's great cities.

Because the knowledge, background, and education of a museum's director are more typically in the field of art than in management and finance, many museums wrestle constantly with the problem of management by individuals who may be brilliant artistically but who are not sympathetic or knowledgeable with respect to financial and operating problems. This at times results in management being shared by two individuals, often very different in temperament and experience, who then, not surprisingly, have difficulty getting along. Excelling at both art and management, Tom is free to pursue a singular and essentially unfettered vision.

Though many people like to think of museums as floating above the fray of financial consideration, the struggle for solvency is enormous and continuous. A business can raise prices in order to cover its costs, but a museum that exists solely to serve the public cannot raise its attendance fees without reducing the size of the public it claims to serve. The Guggenheim has responded by expanding its commercial ventures, such as museum bookstores where catalogs, cards, posters, and so on can be purchased, and entertainment spaces where visitors may dine and special events held. We have also organized exhibits that can be "taken on the road" to reach a larger audience. Once we've incurred start-up costs (locating and retrieving the artwork and producing the catalog) these "roadshow" exhibits achieve economies of scale that increase the museum's net revenue. Our enormously popular motorcycle exhibit, for example, has been mounted in Bilbao, Las Vegas, Chicago, and Memphis as well as New York.

As in business, acquisition is the lifeblood of a modern museum. To cease acquiring works of art, to fail to upgrade the collection, means accepting a static situation comparable to a company that has foregone growth and a dynamic posture. A museum can obtain works of art in three ways: by purchasing, by trading, or by accepting donations. As a result of the financial crunch most museums now face, it is increasingly difficult for them to buy works on the open market. At the Guggenheim, we engage in the continuous upgrading of our collections through a very conservative policy of limited deacquisition, the proceeds from which are secured in a fund reserved solely for new acquisitions. In addition, there are many owners or collectors who, either for tax purposes or because they are extremely generous, or both, offer works of art as outright gifts.

In the end, though, the Guggenheim's most successful response to external financial pressures has been its growth from a rather small museum on New York's Fifth Avenue to a truly international art institution. We have pioneered this global concept, not as a result of a grand design but opportunistically—and of necessity. In addition to bearing all expenses and risks, those who wish to create a Guggenheim presence close to their own far-flung homes pay substantial fees to the New York Guggenheim for its expert advice and services. These international arrangements have in most cases provided substantial net revenue to the Guggenheim, helping to close the gap in our own operating budget. Without global growth, the Guggenheim New York would be a substantially poorer institution—financially and artistically—and clearly would serve the public interest less fully.

Growth also provides economies of scale that favor all of our global partners. Often our major shows premiere in New York and travel to Bilbao, while Deutsche Guggenheim commissions premier in Berlin and then travel to New York and Bilbao. A trilateral collaboration among the Kunsthistorisches Museum in Vienna, Guggenheim New York, and the Hermitage combines their curatorial expertise and collections in ways that make each museum's holdings accessible to broader audiences, encourage shared strategies in publishing and retail ventures and, with some luck, attract long-term international financial support.

As Guggenheim "brand recognition" grows, we have also been successful in gaining

financial support from image-conscious foreign corporations now operating in the United States. Hugo Boss is one of our most important and longstanding corporate patrons. In addition to funding several exhibitions, they also completely fund the biennial Hugo Boss Prize—a major, juried contemporary art invitational whose winner receives $50,000 and a show at the Guggenheim.

One of Tom Krens's more ingenious initiatives has been our "Global Partners" program, in which corporations make donations in return for prominent recognition in all Guggenheim venues. Rather than sponsor an exhibit confined to a single museum, these Global Partners enjoy continual recognition in all Guggenheim museums over months or even years. Deutsche Bank is one of our Global Partners (in addition to having partnered with us on its own Deutsche Guggenheim). Delta Airlines, which provides donations-in-kind, such as gratis flights for museum personnel and artwork shipments, also benefits from worldwide Guggenheim recognition.

No matter how prudent and penny-pinching a museum may be, it cannot thrive (unless richly endowed) without fundraising. Cousin Harry never felt the need nor had the inclination to seek funding from outside the family. When I first became involved with the Solomon R. Guggenheim Foundation in the 1970s, however, I learned we needed to seek financial support from corporations and individuals. To do so, we changed our status from a private to a public foundation, which allowed contributors to take a tax deduction on their contributions.

As we evolved from a private to a public foundation, I knew one of my chief responsibilities was to broaden the base of trustee support for the Guggenheim. I'm proud of the board appointments made during my presidency, including: Mobil chairman and CEO Rawleigh Warner Jr.; Dean Witter chair and CEO Robert M. Gardiner; Lazard-Freres partner and chair Michael David-Weill; Donald Wilson, deputy director of the U.S. Information Agency under President Kennedy; Sea Containers Ltd. CEO James Sherwood, whose holdings include the Hotel Cipriani in Venice, New York's "21" Club, and the Orient Express railroad; investment specialist

John Hilson; William H. Donner Foundation vice president Joseph W. Donner Jr.; former U.S. ambassador to Norway Robin Duke; SCS Communications chairman and CEO Stephen Swid; arts patron Denise Saul; real estate entrepreneur Samuel LeFrak; former ambassador to Great Britain Anne Armstrong; McGraw-Hill chairman Harold McGraw; Kennecott Copper president Frank Milliken; Morgan Bank chair and World Bank director Lew Preston; Gould Corporation chair Bill Ylvisaker; Fogg Museum director Seymour Slive; National Gallery deputy director John Wilmerding; art patron Barbara Jonas; and my cousin Patrick Castle-Stewart (also a grandson, through my mother's sister, of Solomon Guggenheim).

Board members who can afford to are asked to make annual contributions as well as long-term capital gift commitments. Membership clearly has its responsibilities as well as its privileges! In 1980, I decided to make Tom Messer a trustee. Until then, no Guggenheim Museum director had sat on the Guggenheim Foundation board; Tom Krens now occupies that position.

In 1995 I felt the time had come, after twenty-seven years, to turn over the presidency of the foundation to someone younger and more capable of enlisting the financial support of potential donors unknown to our board. Ronald Perelman, a Guggenheim trustee whose holding company MacAndrews & Forbes controls Revlon and a host of other companies, was our choice—highly recommended by Tom Krens and several of his fellow trustees. In early 1996, Ron was elected president, and I was named chairman. (A precedent for such an arrangement had been set in 1969, when I succeeded Harry Guggenheim as president and he assumed the new position of chairman—which he held until his death in 1971.)

Ron and I never sat down to outline the key areas of responsibility for each of us, but we both knew he would work hand-in-hand with Tom Krens in daily operations with a special emphasis on fundraising and the financial health of the institution. I would handle public-relations aspects and take on ceremonial duties both at home and abroad. Ron was a hands-on leader of the foundation, and we were very fortunate that

he assumed this role with great vigor and enthusiasm. He was also extraordinarily generous, contributing $20 million in the course of his tenure as board president.

Meanwhile, Bilbao had brought the Guggenheim to the attention of Peter B. Lewis, the dynamic chairman of the Progressive Corporation in Cleveland, Ohio. Peter was a close friend of Bilbao architect Frank Gehry. We soon invited Peter to join our board, and in his typically bold fashion he immediately began to up the ante for his fellow board members, urging them to an even larger Guggenheim vision and the generosity essential to realizing it.

As time went by, Ron became more enmeshed in his business endeavors. When Peter Lewis, not long after he joined the Guggenheim board, approached Ron suggesting that if Ron would commit $100 million to the foundation, Peter would commit $50 million, Ron was not enthusiastic about the proposal. Soon afterward, he resigned from the board. Peter then went ahead and committed $50 million anyway.

Peter Lewis thus clearly wished to assume a leadership role in the museum's administration. I welcomed his initiative. Having assumed the title of chairman when Ron Perelman succeeded me as president, I felt the time had come to step aside once more so that Peter Lewis would have the stature of the chairmanship to lead the foundation in tandem with Tom Krens, whom he admired as much as I did.

At the board meeting when I announced Peter Lewis as my succeeding chairman, I joked with my fellow trustees that there was only one problem: I was running out of titles. We settled on my becoming honorary chairman. (The position of president was filled, for the first time since Perelman vacated it, in 2004 by New York real estate developer Bill Mack. In February 2005, Bill was promoted to the board's chairmanship. Jennifer Blei Stockman, a former business executive, succeeded him as president.)

For several years, the Krens-Lewis partnership was a powerfully productive one for the Guggenheim. As a principal funding source Peter grounded Tom's ambitions in practicality, while admiring Tom's intelligence and vision. For his part, Tom welcomed Peter's firm hand. But in early 2003, a year and a half after that fateful September 11

meeting when Tom first raised concerns about the Guggenheim's financial condition, Peter issued a public ultimatum to Tom that if he didn't reduce staff and operating expenses resulting in a positive financial performance, Peter would find another Guggenheim director. Tom agreed with Peter's assessment and his conditions. He cut spending, and the museum ended the next fiscal year in the black.

Nevertheless, as time went on Peter and Tom formed increasingly divergent visions for the Guggenheim's future. Peter wanted to focus principally on New York and perhaps modestly extend the museum's foreign presence, while Tom wished to continue pursuing his strategy for a Guggenheim presence around the world. Both visions were openly articulated and discussed at a meeting of the museum's board on January 19, 2005. I attended the entire meeting by conference call and read a statement at the outset, which said, in part:

> "My family and I are enormously grateful to both Tom and Peter. When they were a happy team, the Guggenheim thrived.
>
> "We trustees have been propelled into the middle, between two extraordinary leaders. . . .
>
> "Both have exhibited admirable leadership qualities. I hate to lose either one."

I am told that my thoughts set the tone for what proved to be a remarkably amicable—though clearly difficult—deliberation. In the end, the trustees felt Tom should stay as director; Peter Lewis, in turn, felt compelled to follow his own conscience by relinquishing his chairmanship and resigning from the board, in spite of our entreaties that he not do so. Peter's dedication, leadership, and integrity strengthened our board and earned my undying gratitude.

The trustees continue to support Tom, not because they've been swept away by some romantic vision but because global growth, despite some setbacks, has proven to be one of several valuable strategies for the Guggenheim. Strong financial support from other members of the board, including my son's company and several impressively committed newcomers, augurs well for the future. Other promising recent developments include an agreement announced in early 2005 that a major part of

the collection of postwar European and American art owned by Mrs. Hannelore B. Schulhof and her late husband Rudolf will be donated to the Peggy Guggenheim Collection in Venice. We are deeply indebted to the Schulhofs' generosity and to our Venice director Philip Rylands, who worked with the family to secure their commitment.

Thanks primarily to our former chairman's $15 million challenge, which several of our trustees have responded to with $5 million in gifts of their own, we have also begun efforts to restore the Frank Lloyd Wright building. Such progress—along with record attendance and a terrific exhibit schedule—give us confidence that the Guggenheim will thrive both in the short term and the long run.

An eloquent summation of Tom Krens's tenure to date has been offered by Laurie Norton Moffatt, who wrote (in yet another unpublished *New York Times* letter):

> When Tom Krens took the helm of the Guggenheim in 1988 . . . he understood three things: that the Guggenheim Museum is an architectural icon; that museums have a professional mandate to be accessible and inclusive; and that a museum with a modest endowment, limited resources, and a small patron base must be entrepreneurial to survive. His vision of museums as gathering places for culture, art, and community, his love of art and architecture, and his pragmatic understanding that cultural tourism is good for economic development resulted in a global business that challenges the traditional definition of a museum, making some in the art and culture business uncomfortable.
>
> Fifteen years later, a global Guggenheim has emerged, a museum that has brought the art and culture of the world to its expanded global campus and weathered the storms faced by any entrepreneurial venture. . . .

I share Laurie Moffatt's view of Tom's visionary role. At the same time, I offer my family's unbounded gratitude to Ron Perelman and Peter Lewis for their pivotal financial support over so many years.

EPILOGUE
Global Art as a Family Enterprise

American museums face a difficult future, and the risk of failure is frightening to those of us responsible for them. Expenses escalate while financial support dwindles. A 1986 tax law (since reversed) drastically reduced incentives for individuals to contribute either artworks or money to museums, and corporations are under mounting pressure to reduce their support of the arts. The flap in Washington over the Mapplethorpe exhibition—and Senator Jesse Helms's subsequent amendment to restrict federal support of the arts under certain circumstances—is simply more handwriting on the wall. Additionally, there has been considerable political dialogue over the funding of museum activity by the National Endowment for the Arts, as well as by state and city entities.

The recent history of the Guggenheim is at heart an exemplary response to these external pressures. Tom Messer and Tom Krens have done a fabulous job of making the Guggenheim a success and putting our foundation on the map. I am proud to have been along for the ride and to have supported their endeavors during good and bad times.

I'm particularly grateful to my fellow trustees for their participation in this adventure—and especially so to my wife, Dede, whose unselfish dedication to our role in this enterprise has sustained me through thick and thin.

Last, but not least, I have enormous faith in my four children, each of whom has chosen to carry on the family tradition of active involvement in our shared Guggenheim legacy. My second daughter, Tania McCleery, faithfully serves as a director of the Harry Frank Guggenheim Foundation and chairs its finance and administration

committee. My youngest daughter, Mimi Howe, once an intern and docent at the Peggy Guggenheim Collection in Venice, is now deeply involved with the "Friends of Peggy" advisory board.

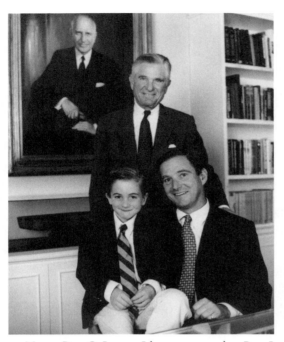

My son Peter O. Lawson-Johnston, my grandson Peter J. Lawson-Johnston, and me under a portrait of Harry in the Harry Frank Guggenheim Foundation boardroom

My third child, Peter, serves on the boards of both the Solomon R. Guggenheim Foundation and the Harry Frank Guggenheim Foundation and is a member of their respective investment committees. Recently, Peter has helped form Guggenheim Partners, a diversified financial services company whose early success is due in small part to the museum-engendered rise of the Guggenheim "brand name." Like the Foundation, Guggenheim Partners has embraced a global business model and serves its clients throughout the world with offices in New York, Chicago, Miami, St. Louis, Los Angeles, Geneva, London, and Hong Kong. The company employs 400 people and is entrusted with over $90 billion of client assets. Completing the circle his great-grandfather began, Peter is now beginning, in concert with his partners, to return some of his resources to the museum as a fourth-generation arts patron.

My eldest daughter, Wendy McNeil, serves as vice president of the Solomon R. Guggenheim Foundation, is a member of the executive and finance committee, and chairs the governance and nominating committee. Wendy has for twenty-five years served as the board's conscience, placing our deliberations and decisions in broader and deeper perspective and extolling the virtues of taking the highest road.

Although each of my children has carved out an area in which to involve themselves within various family enterprises, they collectively share in the management responsibilities of Elgerbar Corporation, which continues to own and operate Solomon's timber plantation in South Carolina.

Though the Solomon R. Guggenheim Foundation has been the principal focus of my career, the rest of Harry's legacy bears mention.

One of my biggest challenges after Harry died was to reactivate his own Harry Frank Guggenheim Foundation and its research into "man's relation to man," specifically the causes and consequences of dominance, aggression, and violence. We needed proper leadership, a wise and prestigious board, and a proper staff. Mason Gross (then just retired as president of Rutgers University) was recommended to me by my father-in-law, Donald Hammond, who knew him well. Mason was receptive to heading our foundation, if he could enlist two noted Rutgers anthropologists with the unlikely names of Lionel Tiger and Robin Fox.

My daughters Mimi Howe, Tania McCleery, and Wendy McNeil

This took place in 1972, after a serious operation had caused the resignation of Dr. Henry Allen Moe, our first president, appointed to the job by Harry. It had been my sad duty, as chairman of the foundation's board, to accept Dr. Moe's resignation—sad because of his long, distinguished career as head of the foundation, his impeccable reputation as an intellectual giant among scholars, and his wide acquaintanceship among artists.

Mason Gross set the foundation on a path of grant-giving to carefully screened applicants. Professors Tiger and Fox were an able team who carried out the program for a dozen years before a different system was instituted under the new leadership of Dr. Floyd Ratliff, who succeeded Mason's successor, Donald Griffin, as president.

The foundation's freedom to explore any avenue of scientific research in search of light on man's behavior has occasionally invited controversy and criticism. Floyd Ratliff, during his presidency, gave this example:

> Over the years we have supported several basic studies on sexual attraction, fertility, and reproductive success in lower animals—including such diverse topics as the extravagant sexual displays and violent competition of male bower birds, and the effects of dominance and aggression on fertility in female baboons. Recently an investigator convinced us of the need for an objective study on courtship interactions between women and men modeled on proven methods of ethology, a branch of the science of animal behavior. He was able to describe flirtation observed in singles bars as a relatively stereotyped pattern of behavior, a sort of "ritual dance" he saw repeatedly in initial encounters between different women and men. Interestingly, too, he found that the women involved were much more conscious of these patterns of behavior than were the men, just as researchers into primate behavior have begun to recognize and emphasize "proceptivity," the active role that female primates take in sexual encounter.
>
> The animal studies attracted little attention outside of scientific circles. But newspaper reporters quickly spotted and widely publicized the flirtation study, and the foundation was ridiculed and criticized for the waste of money on such a "trivial" pursuit. (The long-range objectives of the foundation and the scientific background and implications of the study received no comment.) Letters soon came from several "concerned citizens" telling us how the money could have been better spent on some other cause (generally one far outside the scope of our stated objectives). Did the study actually produce significant results with direct relevance to our program on dominance, aggression and violence? We believe so—although only time will tell. Would we support this study if we had it all to do over again? Probably—given the same circumstances. Our choices of projects are based on professional assessments rather than on public acclaim.

Former New York University president Jim Hester succeeded Dr. Ratliff as president in July 1989 and immediately initiated an objective assessment of our program. The result was the confirmation of the foundation's principal focus, with new emphasis on the study of violence in the modern world. This new emphasis led to a series of studies—under the able direction of Karen Colvard and Joel Wallman—on a variety of issues such as violence in the media and entertainment, gun violence, violent children in the inner city, nationalism and violence, and the relationship between punishment and violence. Jim energetically disseminated research findings, creating the *HFG Review* to provide such information on a continuing basis. He also held a competition to produce an undergraduate curriculum to acquaint college students with the role of violence in the history of human behavior.

As Jim's retirement approached in 2003, we appointed a most worthy successor in Josiah Bunting III. Like Jim Hester a Rhodes Scholar, Si is a decorated Vietnam veteran, noted author of fiction and nonfiction, former president of Briarcliff College and Hampden-Sydney College, and former headmaster of The Lawrenceville School (where I served as board chairman during his tenure); he had just stepped down as superintendent of Virginia Military Institute (which he had coeducated with remarkable success) when we invited him to direct the Harry Frank Guggenheim Foundation. We fully expect that Si's energy, intelligence, and commitment to the essential role of new ideas in bettering humankind will take the foundation to an entirely new level of accomplishment and recognition.

The Harry Frank is often confused with the highly publicized John Simon Guggenheim Memorial Foundation, established in 1925 by my great-uncle, U.S. Senator Simon Guggenheim, in memory of his son who died of pneumonia at Phillips Exeter Academy in New Hampshire. The foundation's purpose is to "promote the advancement and diffusion of knowledge and understanding, and the appreciation of beauty, by aiding without distinction on account of race, color or creed, scholars, scientists and artists of either sex in the prosecution of their labors." Long overseen by my late cousin Roger Straus, the John Simon now provides about 300 grants annually (the coveted "Guggenheim Fellowships") from a pool of about 4,000 applicants. Though I have no role in this foundation, over the years I have met many of

the recipients and, without exception, have remembered them happily.

Another inheritance from Harry was Guggenheim Brothers, a family partnership formed in 1916 to discover and develop mining enterprises. One Guggenheim Brothers endeavor was their investment of much of the proceeds of the 1923 sale of the Chuquicamata copper mine in Chile in the development of a vast nitrate mining operation in the Atacama Desert near the "Chuqui Mine" they had just sold. Exactly fifty years later, in 1973, I became chairman of this company, Anglo Lautaro Nitrate Company. The venture was never a smashing success because synthetic nitrate, cheaper to produce, was invented by the Germans around that time. On a happier note, I spent forty-seven years with another Guggenheim Brothers' mining venture, Pacific Tin Corporation, later renamed Zemex, which was sold in 2003, during my chairmanship.

We've also had to manage two important real estate holdings. The first is Falaise, Harry Guggenheim's Long Island estate, which was bequeathed to Nassau County, under the condition that the county properly maintain it. The other is Daniel Island, the property directly across from the city of Charleston, South Carolina, which Harry bought in 1947. When Harry died the island was bequeathed to the Harry Frank Guggenheim Foundation. We on the foundation board worked for years to create a development plan that would preserve much of its natural beauty and bring economic uplift to the Charleston region. With the sale of Daniel Island to the Daniel Island Company in 1997, we believe we accomplished both of those ambitious goals. Daniel Island now boasts golf courses, churches, and a school—a boon to the entire Charleston metropolitan area and a great tribute to Harry's memory.

Though assisted by generations of talented curators and staff members—and shaped by the work of many world-renowned artists—the ascent of the Solomon R. Guggenheim Museum is due principally to the work of Solomon Guggenheim, Harry Guggenheim, Peggy Guggenheim, Tom Messer, Tom Krens, the Guggenheim Foundation's trustees—perhaps two dozen people at most. My own Guggenheim

career, as I see it in retrospect, has been in some cases to identify such people as prospective leaders in the Guggenheim cause and in all cases to foster their relationships with the museum and often with each other. My friend Stretch Gardiner was kind enough to bring this last point home at the museum's fortieth-anniversary gala. (Though the gala was held in my honor, I was reluctant to invite a number of my best friends for fear of inflicting the $500-a-plate museum donation on them!) Stretch had this to say:

> Peter, your grandfather Solomon Guggenheim and your Cousin Harry Guggenheim would be very proud of you.
>
> It was you who concluded the momentous gift of the Peggy Guggenheim collection in 1974, adding an international flavor to the New York foundation. The Venice museum continues to be a jewel in the Guggenheim crown.
>
> It was you who oversaw the inauguration of the Thannhauser wing in 1978.
>
> It was you who guided the transition from Tom Messer to Tom Krens in July 1988, acting on Messer's suggestion that Krens be his successor.
>
> It was you who had the courage to initiate the expansion and renovation of this building, closing the museum for two years to assure that the work would be done properly and last for years to come.
>
> It was you who led the board of trustees in the innovative and visionary agreement with the Basque government to open the Guggenheim Museum Bilbao in 1997, thus further increasing the worldwide reach of the foundation.
>
> So, Peter, I say again, your grandfather and your cousin must be proud indeed of the way in which you have handled the responsibilities given to you in 1969. I can also tell you, as one who served on the board of trustees for sixteen years, that the board is deeply grateful for the leadership which you have provided. . . .

A mosaic composed of tiny details, one's career yields much satisfaction but only a few "big" thoughts worth passing along to readers of this book. One is that businesses and museums can learn much from each other. Most museums can be run

more efficiently by employing more sophisticated management practices. On the other hand, I believe that art is an ennobling element of our pragmatic life and is particularly beneficial to our commercial and technological civilization. Business leaders, particularly in an increasingly global economy, can accomplish much by leading their employees into the world of art. And if political as well as business leaders can bring themselves to see all art and culture as our common heritage, transcending national barriers, these endeavors can become a powerful force for peace in the world.

Finally, perspective is everything. I've been proud, humbled, honored, and lucky to play a part in the Guggenheim's remarkable adventure. But I've been even more proud, humbled, honored, and lucky to marry the right woman and enjoy four wonderful children, their spouses, and their own ten wonderful children. When I look into those youngsters' eyes, I see beyond the horizon of my own life and my children's lives, and once in a while I wonder which of them might grow up to carry on our great family tradition.

I'll never know for sure, so to be on the safe side—and because I remember well how much I cherished the letters I received from Grandpa Solomon—I write each and every one of those ten grandchildren on each and every one of their birthdays.

ACKNOWLEDGMENTS

No book is a solitary endeavor, and I am delighted to recognize the many people who have helped create this one.

I begin with former Guggenheim development officer Mimi Poser, who first suggested I write this book after listening to me recount a few family stories during a slow taxi ride through Manhattan traffic. My late friend, the acclaimed author and playwright Bill McCleery, launched me on this journey by helping me get ideas and memories out of my head and onto paper.

For leading us to Marianne Strong, who fed the project's flame through her valiant attempts to find a publisher for it, I thank my friend and neighbor Ted Crane.

For their helpful suggestions as the manuscript progressed—and more importantly for their stellar stewardship of the Solomon R. Guggenheim Museum—I extend my deepest thanks to Tom Messer, the museum's director from 1961 through 1988, and Tom Krens, its director since 1988.

I am deeply thankful for the contributions of my late half-brother, Michael Wettach, whose far-reaching memories of our shared childhood broadened and deepened Chapter 2.

I also thank Karole Vail—assistant curator at the Guggenheim, Peggy Guggenheim's granddaughter, and my cousin several times removed—for her excellent improvements to the chapter on her grandmother.

Anthony Calnek, the Guggenheim's deputy director for communications and publishing, has kindly lent his extensive editorial skill—and photographs from the museum's archive—to this effort.

For decades of friendship, and for calling this book to the attention of ISI Books, I thank William F. Buckley Jr.

ISI's editor in chief Jeremy Beer and publisher Jeffrey O. Nelson have done much to make this a better book and an enjoyable enterprise.

For his marvelous foreword to the book, and for the energy, insight, and imagination he now brings to the Harry Frank Guggenheim Foundation, I thank Josiah Bunting III.

Closer to home, I remain deeply grateful to Mary Donat—who, in addition to serving as my right *and* left hands on this and a great many other projects—performed the miracle of translating my handwriting into neat typescript.

I would also like to thank my collaborator, Rob White. By shaping and reshaping *Growing Up Guggenheim* in response to excellent suggestions we received from many quarters, Rob helped me discover my truest voice and the truest story about my family's accomplishments and its legacy.

I end where all gratitude begins, with my wife Dede, our children, their spouses, and our grandchildren. My love to you all.

PETER LAWSON-JOHNSTON
March 2005

INDEX

Africa, 19
Alaska, 9
Allen, the chauffeur, 10
American Airlines, 74
American Federation of Arts, 84, 89
American Smelting and Refining Corporation, 9
Anaconda Company, 9
Anglo Lautaro Nitrate Company, 70, 140
Angola, 9
Ardanza, José Antonio, 118
Ardrey, Robert, 68
Argentina, 19
Armani, 3, 124
Armstrong, Anne, 131
Arp, Jean, 97
Art of This Century, 98
Association of Art Museum Directors, 111
Australia, 19
A.Y. and Minnie Mines, 8
"Aztec Empire, The," 126

Baker, Russell, 4, 55
Baltimore Sun, 4, 55, 56
Barney, Matthew, 126
Baruch, Bernard, 66fig
Basque Country, Spain, 1–2, 116–20

Bassett, Jane, 43
Bauer, Rudolf, 15, 21
Beckett, Samuel, 96
Berlin, Germany. *See* Deutsche Guggenheim
Best, Ed, 37
Bilbao, Spain. *See* Guggenheim Museum Bilbao
Board of Standards and Appeals (BSA), 92–94
Boss, Hugo, 130
Bostwick, Pete, 32
Bovril, 26
Boyd, the butler, 11, 12
Brancusi, Constantin, 97, 126
Braque, Georges, 15, 97
Brazil, 19
Breton, André, 97–98
Bulova, Mrs., 88
Bunting, Josiah, III, xi, 139
Burri, Alberto, 85
Byington, Homer, 58
Byrd, Harry, 62

Cain Hoy, 62, 75, 79, 80
Calder, Alexander, 97
Casey, Al, 74
Castle-Stewart, David, 33fig
Castle-Stewart, Earl of, 25, 33fig
Castle-Stewart, Eleanor, 25, 33fig, 44, 65, 99

Castle-Stewart, Patrick, 33fig, 131
Castle-Stewart, Robert, 33fig
Castle-Stewart, Simon, 33fig
Chagall, Marc, 14, 15
Chandler, John, 110
Chandler, Norman, 74, 75
Chandler, Otis, 74, 75
Chevaliers de la Table Rond, Les (Cocteau), 97
Chicago Tribune, 62
Chile, 9
Chuquicamata Copper Mine, Chile, 9
Cleaveland, Norman, 58
Cocteau, Jean, 96, 97
Colorado, 8
Colvard, Karen, 139
Congo, 9
"Constantin Brancusi: The Essence of Things,"
 126
Cuba, 3

Dali, Salvador, 97
Daniel and Florence Guggenheim Foundation,
 64, 80
Daniel Guggenheim Fund for the Promotion of
 Aeronautics, 64
David-Weill, Michael, 130
Davis, John H., 10, 64
Dean Witter, 130
Delaunay, Robert, 14
Deutsche Bank, 120
Deutsche Guggenheim, 3, 81, 120, 129, 130
Diana, Princess, 118fig
Donner, Joseph W., Jr., 131
Doolittle, James, 62, 68
Dorsey, Buck, 55
Dubuffet, Jean, 85, 94
Duchamp, Marcel, 96, 97
Duetsche Bank, 130
Dukakis, Michael, 111
Duke, Robin, 92, 131

Duncan, Isadora, 96
Dunlap, Fannie, 26

Easton, Glenn, 76, 86–87
Eisenhower, Dwight D., 64–65
Eisenman, Peter, 93
Elgerbar Corporation, 137
Erburu, Bob, 74
Ernst, Max, 3, 97–98, 102
Eton, 26, 79
Everest, Hank, 62

Fairbanks, Douglas, Jr., 49
Farrar, Straus, and Giroux, 73
Feldspar Corporation, 57–58
Field, Kenny, 46
Finney, Humphrey, 78
Fitch, James Marston, 93
Florida Racing Commission, 35
Fogelson, Buddy, 78
Fogg Museum, 131
Fontana, Lucio, 85
Fountaine, George, 61, 66, 67, 69, 71, 79
Fox, Robin, 137, 138
"Friends of Peggy," 108, 136

Gallo, Mo and Lillian, 32
Garcia Villa, Remedios, 83–84, 89
Gardiner, Robert "Stretch," 117, 130, 141
Garson, Greer, 78
Gauguin, Paul, 89
GE Capital, 122
Gehry, Frank, x, 1, 2, 117–18, 123, 132
Giacometti, Alberto, 97
Gide, André, 96
Gleizes, Albert, 14
Glueck, Grace, 111
Goddard, Robert H., 64

Goldberger, Paul, 114
Goldman, Emma, 96
Gould Corporation, 131
Grace, W. R., 67
Graves, Michael, 93
Griffin, Donald, 138
Gross, Mason, 137–38
Growing Up (Baker), 55
Guadalajara, Mexico, 121–22
Guggenheim, Alicia, 3, 62–65, 84
Guggenheim, Barbara, 26fig, 33fig; childhood of,
25–26; Guggenheim, Harry Frank, and,
76–77; Lawson-Johnston, Peter, as
Guggenheim heir and, x, 72; lifestyle of, 26–
29, 31–32; marriages of, 26–29, 32–34,
37–39, 42–44; as mother, 29–30, 35–36,
46–47; philanthropy of, 45–46; religion
and, 40–41; Solomon R. Guggenheim
Foundation and, 65
Guggenheim, Barbara (great-grandmother), 8,
13, 23
Guggenheim, Benjamin, 8, 13, 95
Guggenheim, Cora, 8
Guggenheim, Daniel, 3, 8, 9, 61
Guggenheim, Edmund, 9
Guggenheim, Eleanor. *See* Castle-Stewart, Eleanor
Guggenheim, Florence, 65
Guggenheim, Gertrude, 25, 33fig, 99
Guggenheim, Harry Frank, 9, 66fig, 78fig; as
family patriarch, 61, 64–81; Guggenheim,
Barbara, and, 76–77; Guggenheim, Peggy,
and, 99–101; Guggenheim legacy and, 3;
as horseman, 46, 61–62, 78; Lawson-
Johnston, Peter, as heir of, ix–xi, 68–73, 78–
81; legacy of, 137–40; marriage of, 62–64;
Messer, Tom, and, 86; *Newsday* and, 62–63,
70, 73–75; personality of, 75–76
Guggenheim, Irene, 9–13, 19–20, 21fig, 22, 23,
33fig
Guggenheim, Isaac, 8, 23
Guggenheim, Jenette, 8

Guggenheim, Meyer, 100
Guggenheim, Meyer (great-grandfather), 2, 7–9
Guggenheim, Murry, 8, 9
Guggenheim, Peggy: art collection of, 5, 13, 96–
98, 98–102, 105–8, 115; autobiography of,
3; background of, 95–96; family relation-
ships of, 98–99; Guggenheim, Harry Frank,
and, 99–101; Guggenheim legacy and, 3;
marriages of, 96, 98; philanthropy of, 13
Guggenheim, Robert, x, 64–65
Guggenheim, Rose, 8
Guggenheim, Simon, 8
Guggenheim, Simon (great-great-grandfather), 7
Guggenheim, Solomon R., 17fig, 33fig; abstract
art collection of, x, 13–21; death of, 19,
22; family background of, 7–9; Lawson-
Johnston, John, and, 28; Lawson-Johnston,
Peter, relationship with, 22–23; legacy of,
2–5; lifestyle of, 9–13; philanthropy of, 13;
Rebay von Ehrenwiesen, Hilla, and, 13–21;
religion and, 22; Wettach, Freddy, Jr. and,
29
Guggenheim, William, x
Guggenheim Brothers, 28, 56, 61, 66, 67–69,
80, 140
Guggenheim.com, 122
Guggenheim Fellowships, 13
Guggenheim Hermitage Las Vegas, x, 3, 81, 120–
21, 129
Guggenheim Jeune, 96, 98
Guggenheim Museum Bilbao, x, 1–3, 6, 81, 116–
20, 124, 132
Guggenheim Museum SoHo, 122
Guggenheim New York, 18; Arts Advisory Com-
mittee of, 87, 88; evolution of, 3–4; expan-
sion of, 4, 81, 91–94; functions of, 84; glo-
bal, x, 4, 5, 109–34; Guggenheim, Harry
Frank, and, 76–77; Lawson-Johnston, Pe-
ter, and, 81; legacy of, 2–5; management
of, x–xi; Rebay von Ehrenwiesen, Hilla, and,
15; Thannhauser collection and, 89–91;

Wright, Frank Lloyd, and, x, 2, 5, 15, 18, 20, 81, 84, 89, 91, 92, 93
Guggenheims, The (Davis), 10, 64
Gunther, the chauffeur, 10
Gwathmey Siegel & Associates, 92, 93

Haacke, Hans, 88
Hackett, Spencer, 39–40
Hammond, Donald, 137
Hammond, Dorothy ("Dede"). *See* Lawson-Johnston, Dorothy ("Dede")
Hanes, John W., 70, 72, 74, 75, 78, 79
Hanhardt, John, 124
Harry Frank Guggenheim Foundation, 3, 68, 80, 137–40
Hay, John, ix
Heatter, Gabriel, 11
Helion, David, 106–7
Helion, Nicholas, 106–7
Helms, Jesse, 135
Hemingway, Ernest, 96
Hermitage, Russia, 120
Hester, Jim, 139
HFG Review, 139
Hilson, John, 131
Hirsch, Bill, 35
Hirsch, Max, 35
Hitler, Adolf, 41, 47
Hollein, Hans, 115
Hoover, Herbert, 61
Hopps, Walter, 124
Howe, Mimi. *See* Lawson-Johnston, Mimi
Humphrey, Hubert, 73

IBM, 23
Idaho, 12
Iglehart, Stewart, 32
Institute of Contemporary Art (Boston), 84
Internal Revenue Service (IRS), 35

International Association of Art Critics, 126
IRS. *See* Internal Revenue Service
Ivy Lee, 75

John Simon Guggenheim Memorial Foundation, 80, 139
Johnson, Philip, 93, 118
Jonas, Barbara, 131
Jørn, Asger, 85
Juan Carlos, King, 1, 118, 119
Jules, the valet, 11

Kandinsky, Wasily, 14, 15, 60, 97
Kandinsky Society, 101
"Kazimir Malevich: Suprematism," 126
Keller, Ted and Nan, 39–40
Kennecott Cooper, 9
Kennecott Copper Corporation, 67, 73, 131
Kennedy, John F., 130
Klee, Paul, 15, 60, 97
Koons, Jeff, 119, 120
KPMG accounting firm, 119
Krens, Tom, 4, 90–91, 106, 135; "Global Partners" program and, 130; Guggenheim Berlin and, 3; as Guggenheim director, 81, 109–34; Guggenheim expansion and, x, 113–22; Guggenheim Hermitage Las Vegas and, 3, 120–21; Guggenheim legacy and, 3; Guggenheim Museum Bilbao and, 3, 116–20; Lewis, Peter, and, 132–33; Messer, Tom, vs., 125–26; style of, 114–15, 123–26; WCMA and, 109–12
Kuala Lumpur, Malaysia, 58
Kunsthistoriches museum, Austria, 120, 129

Ladew, Harvey, 42
Las Vegas Guggenheim. *See* Guggenheim Hermitage Las Vegas

Lawrenceville School, The, x, 39–40
Lawson-Johnston, Dorothy ("Dede"), 52–55, 53fig, 59, 71, 72, 101, 118fig, 135
Lawson-Johnston, John, 27fig, 58fig; death of, 54; drinking problem of, 54; Guggenheim, Barbara, marriage to, 26–28; Lawson-Johnston, Peter, relationship with, 37–38, 45, 49–50, 54
Lawson-Johnston, Mimi, 53, 136, 137fig
Lawson-Johnston, Orma, 54
Lawson-Johnston, Ormond, 26
Lawson-Johnston, Paulette, 45, 49, 54, 58fig
Lawson-Johnston, Percy, 53
Lawson-Johnston, Peter, 33fig, 53fig, 136fig; career of, 55–60; childhood of, 29–32, 34–36, 39–42; college and, 50–52, 55; Guggenheim, Barbara, relationship with, x, 46–47; Guggenheim, Solomon R., and, 9–13, 22–23; as heir of Guggenheim, Harry Frank, ix–xi, 68–73, 78–81; Jewish roots of, 40–41, 51–52; Lawson-Johnston, John, relationship with, 37–38, 45, 49–50, 54; marriage of, 52–55; in military, 47–48; *Newsday* and, 73–75; religion and, 40–41
Lawson-Johnston, Peter J., 136fig
Lawson-Johnston, Peter O., 53, 57, 136, 136fig
Lawson-Johnston, Tania, 53, 57, 135, 137fig
Lawson-Johnston, Wendy, 53, 57, 136fig, 137fig
Lazard-Freres, 130
Lee, Sherman, 124
Lee, Sir Henry S., 58–59
LeFrak, Samuel, 131
Léger, Fernand, 14
Lengnau, Switzerland, 7
Lewis, Anthony, 1, 2
Lewis, Peter, 123, 126, 132–33, 134
Lindbergh, Charles, 64, 68
Lodge, Henry Cabot, 66fig
Los Angeles Times, 74
Lucchesi, Mury, 48
Lufthansa, 127–28

MacAndrews & Forbes, 131
Mack, Bill, 132
Magritte, René, 97
Malaysia, 58
Malevich, Kazimir, 126
Mansfield, Jayne, 44
Maryland Civil Defense Agency, 56
Maryland Classified Employees Association, 56
Massachusetts Museum of Contemporary Art (MASS MoCA), 112–13, 114
Masterpiece Theater, 55
"Matthew Barney: The Cremaster Cycle," 126
McCleery, Tania. *See* Lawson-Johnston, Tania
McCormick, Colonel Robert R., 62
McGraw, Harold, 131
McGraw-Hill, 131
McNeil, Wendy. *See* Lawson-Johnston, Wendy
Meier, Richard, 93
Merman, Ethel, 44
Messer, Tom, 102, 135; background of, 83–84; Guggenheim, Harry Frank, and, 86; Guggenheim, Peggy, and, 99–101, 102–3; as Guggenheim director, 81, 83–94; Guggenheim expansion and, x, 4, 91–94, 113; Guggenheim legacy and, 3; Krens, Tom, vs., 125–26; marriage of, 83–84; Rebay von Ehrenwiesen, Hilla, and, 15; resignation of, 109
Mexico, 8, 121–22
Meyer, Barbara (great-grandmother). *See* Guggenheim, Barbara (great-grandmother)
M. Guggenheim Sons, 8
Miller, Betty, 43
Miller, Stuart, 58
Milliken, Frank, 67, 131
Miró, Joan, 77, 97
Mobil, 130
Modigliani, Amedeo, 15
Moe, Henry Allen, 137
Moffatt, Laurie Norton, 118, 134
Mondrian, Piet, 60, 97

Monet, Claude, 90
Montebello, Philippe de, 124
Monterrey, Mexico, 8
Moore, Charles, 110
Moore, Henry, 97
Morgan Bank, 67, 131
Morgan Stanley, 126
Moses, Robert, 77
Motherwell, Robert, 98
Mount Sinai Hospital, 13
"Moving Pictures," 126
Moyers, Bill, 70, 73–74, 75
Murder! Murder! (Vail), 96
Muse, The (Brancusi), 87–88
Museums Council of New York, 18

Namm, Andy, 31
Nash, David, 88
National Endowment for the Arts, 135
National Gallery, 131
Newsday, 3, 62–63, 70, 73–75
New York Daily News, 36, 62
New York Mirror, 38
New York Times, 1, 55, 88, 91, 111, 113, 114, 127, 134
New York Times Magazine, 124
Nixon, Richard, 73–74
Norman Rockwell Museum, 118

Obre, Henry, 12, 53; drinking problem of, 42; Guggenheim, Barbara, marriage to, 37–39, 42–44, 46
Oliver, George, 32
Out of This Century (Peggy Guggenheim), 96

Pacific Tin Consolidated Corporation, 56–60, 61, 65
Page, Walter, 67

Palazzo Venier dei Leoni, Venice, Italy, 3, 4, 98–100, 115
Panza di Biumo, Giuseppe, 114
Partridge, Pat, 62
Patterson, Alicia. *See* Guggenheim, Alicia
Patterson, Captain Joseph Medill, 62
Peat, Jean, 36, 41
Peeples, John, 70
Peggy Guggenheim Collection. *See* Guggenheim, Peggy
Pei, I. M., 93
Pennsylvania, 2, 7
Perelman, Ronald, 131, 134
Peters, Ralph, 67
Peters, William Wesley, 90, 92
Peterson, William, 93
Philadelphia, 2, 7
Picasso, Pablo, 15, 60, 89, 90, 124
Pier, Mauá, 120–21
Pollock, Jackson, 98
Pompidou, Mme. Claude, 100–101, 115fig
Ponsell, Rosa, 53
Pound, Ezra, 96
Prendergast, Maurice, 110
Preston, Lew, 131
Progressive Corporation, 132
Prohibition, 26–27

Quesdada, Pete, 62
Qui Sait, 35

Ratliff, Floyd, 138–39
Rauschenberg, Robert, 124, 127
Rawls, Bill, 79
Ray, Man, 97
Read, Henry, 97
Rebay von Ehrenwiesen, Hilla, 6, 13–21, 14fig, 17fig, 31, 77, 84–86, 96
Revlon, 131

Rich, Daniel Catton, 84
Richter, Gerhard, 120
Rio de Janeiro, 120–21
Roach, Kevin, 93
Rockefeller, David, 114
Rogers, Carroll, 57
Rome, Italy, x
Roosevelt, Franklin D., 11
Rosenblum, Robert, 124
Rosenquist, James, 120, 124
Roswell Museum, New Mexico, 84
Rothko, Mark, 98
Rudenstine, Angelica, 102
Rumney, Laurance, 108
Rumney, Sandro, 106–7, 108
Russia, 120, 127–28
Rylands, Philip, 101, 118fig, 125, 134

Salzburg, Austria, 115–16
Sanford, Laddie, 32
Schulhof, Mrs. Hannelore B., 134
Scotland, 12
SCS Communications, 131
Sea Containers Ltd., 130
September 11, 2001, 123, 126, 132
Serra, Richard, 118
Seurat, Georges, 15
Sherwood, James, 130
Show Jumping Hall of Fame, 29
Slive, Seymour, 131
Societe Generale de Belgique, 9
Sofia, Queen, I, 115fig, 118, 119
Solomon, Deborah, 124
Solomon R. Guggenheim Collection of Non-
 Objective Painting, 15, 98
Solomon R. Guggenheim Foundation, 15, 17,
 65; Lawson-Johnston, Peter, and, 67–68,
 73, 81; lawsuit brought against, 105–8;
 Peggy Guggenheim Collection and, 95; pur-
 pose of, 81

Solomon R. Guggenheim Museum of New York
 City. *See* Guggenheim New York
Sotheby's, 88
South Carolina, 12
Soviet Union. *See* Russia
Stevenson, Adlai, 63
St. Mary's Episcopal Church, 39–40
Stockman, Jennifer Blei, 132
Straus, Gladys, 72–73
Straus, Oscar, II, 67, 73
Straus, Roger, 73, 139
Styne, Julie, 44
Sual, Denise, 131
Sweeney, James Johnson, 84, 85, 86
Swid, Stephen, 125, 131
Switzerland, 7, 8

Taiwan, 122
Tàpies, Antoni, 85
Tate Gallery, London, 59–60
Taylor, Mark, 110, 127
Tejan, Fred, 32
Temple Emanu-El, 22
Thannhauser, Hilde, 90
Thannhauser, Justin, 3, 89–91, 94
Thiele, Albert, 56, 58, 66–67, 73
Thomas Fortune Ryan, 9
Thompson, Joe, 112
Thompson, Kay, 25
Tibbett, Lawrence, 49
Tiger, Lionel, 137, 138
Times Mirror Company, 74–75
Titanic, 13, 95
Town & Country, 4
Trillora Court, 10–11, 16, 23, 25
Trust for Cultural Resources of the City of New
 York, 114
Tutt, Thayer, 67
Twain, Mark, ix
Twining, Nate, 62

UN. *See* United Nations
United Nations (UN), 58
United States and Cuba (Harry Frank Guggenheim), 61
Unver, Felix, 115

Vail, Clovis, 108
Vail, Jacqueline, 101
Vail, Julia, 108
Vail, Karole, 3, 101, 105, 107–8
Vail, Laurence, 96, 98
Vail, Mark, 108
Vail, Pegeen, 96, 98, 105
Vail, Sindbad, 96, 98, 101, 103, 104–5
Van de Maele, Joan, 73
Vanderbilt, Alfred, 61
Van Gogh, Vincent, 17, 89
Van Kemmel, Eugéne, 110
Versace, 124
Viola, Bill, 120
Virginia, University of, 50, 55

Wadsworth, Jack, 122, 126
Wallman, Joel, 139
Warner, Rawleigh, Jr., 130
Washington, George, 12
West, Cornel, 110, 127
Wettach, Freddy, Jr., 29fig, 33fig; drinking prob-
lem of, 36–37, 42, 44; as father, 35–36; Guggenheim, Barbara, marriage to, 28–29, 32–34; as horseman, 32–34
Wettach, Michael, 33fig, 43, 53; career of, 44–45; childhood of, 30–32, 34–35, 39; Guggenheim, Solomon R., and, 9–10; as horseman, 28–29; Lawson-Johnston, Peter, as Guggenheim heir and, 72; Solomon R. Guggenheim Foundation and, 65
Wettach, Pamela, 30
Whitney, 85, 112, 113, 124
Wiley, Hugh, 42
William H. Donner Foundation, 131
Williams College Museum of Art (WCMA), 109–12
Wilmerding, John, 131
Wilson, Donald, 130
Wittingham, Charlie, 78
Works Progress Administration, 84
World Bank, 131
World War I, 9, 12, 61
World War II, 28, 61, 85
Wright, Frank Lloyd, x, 2, 5, 15, 17fig, 18, 20, 77, 81, 84, 89, 91, 92, 93, 118, 134
Wright, Ogilvana, 91

Ycaza, Manuel, 79
Ylvisaker, Bill, 131
Young, George, 59